PAINT YOURSELF POSITIVE

PAINT YOURSELF POSITIVE

Colourful, creative watercolour

JEAN HAINES

SEARCH PRESS

I dedicate this book to my husband John. Before
I met you I knew what I couldn't do. The most
important lesson you taught me is that 'I can'.

Thank you for always believing in me.

Love Jean.

ACKNOWLEDGEMENTS

I have thought so hard about who to thank for helping me write this book. But it is you, the reader, who I owe my gratitude to most of all. Without you I could not be an author. Without the encouragement of so many people in my life I would not be writing, creating or where I am today as an artist.

I owe my positive attitude to my husband, who has always given me wonderfully uplifting advice; my stepmother, who taught me that happiness is not to be found in what we own but in how we face life; and my grandfather, who taught me from an early age to always look for the beauty around me.

I am grateful for all the hosts of my workshops worldwide, and to everyone who has attended them telling me stories confirming painting can definitely change lives in miraculous ways.

We all can paint ourselves positive.

Thank you to everyone who has been a part of this book's incredible journey.

First published in 2019

Search Press Limited
Wellwood, North Farm Road,
Tunbridge Wells, Kent TN2 3DR

Illustrations and text copyright © Jean Haines 2019

Photographs by Roddy Paine Photographic Studios on location at the author's house. Additional photographs author's own.

Photographs and design copyright © Search Press Ltd 2019

Paperback ISBN: 978-1-78221-653-7
Hardback ISBN: 978-1-78221-774-9

The Publishers and author can accept no responsibility for any consequences arising from the information, advice or instructions given in this publication.

Suppliers
If you have difficulty in obtaining any of the materials and equipment mentioned in this book, then please visit the Search Press website for details of suppliers:
www.searchpress.com

Author's welcome

Painting can lift our spirits and help us to overcome the ups and downs of our lives.

Life can seem far richer when we embrace a positive attitude. Some people may be born to see the best in any situation; I am not convinced that I was. However, from the minute I learned how to paint, my mood and attitude changed for the better. I became a far more positive person and learned to see the best in every situation I was challenged with. Like many people, I have faced quite a few challenges in my life. Some small, some not so small.

I discovered that painting can be intensely therapeutic. Yes, it is calming, but also brings with it an unexpected feeling of positivity that, when harnessed correctly, can be life-changing. I look back and know exactly how paint and the use of colour has helped me on so many occasions. Painting regularly is healthy for both soul and mind. It is enriching, rewarding and can be healing. It can also energize. It can open our eyes to seeing things completely differently. There are endless benefits to spending personal time creating; benefits which we are often completely unaware of.

Art can be more than a distraction from our daily routine; it can add to it in so many ways.

When painting, I am able to reach a place in my mind that distracts me from any form of pressure or stress. That is the truth. In fact, I now have colour exercises which I turn to on a regular basis to literally feel better. I find peace of mind, lift my mood, recharge my energy and become completely motivated purely by the time I have spent creating.

How I work with colour is like a form of yoga, in that I can still myself to the point that I feel like a whole new person when I put my brushes down. I feel I have exercised not just my mind, but my whole being. And when I come out of a painting session, whatever may have troubled me before often seems less troublesome!

It may be difficult to imagine that painting alone can help us overcome life's hiccups and also improve our lives, but it is absolutely true: It can. It has. Through the pages of this book I am going to show you how you too can paint yourself positive.

We need very little to get started: just the will to try.

You can do this. Let's start by feeling positive!

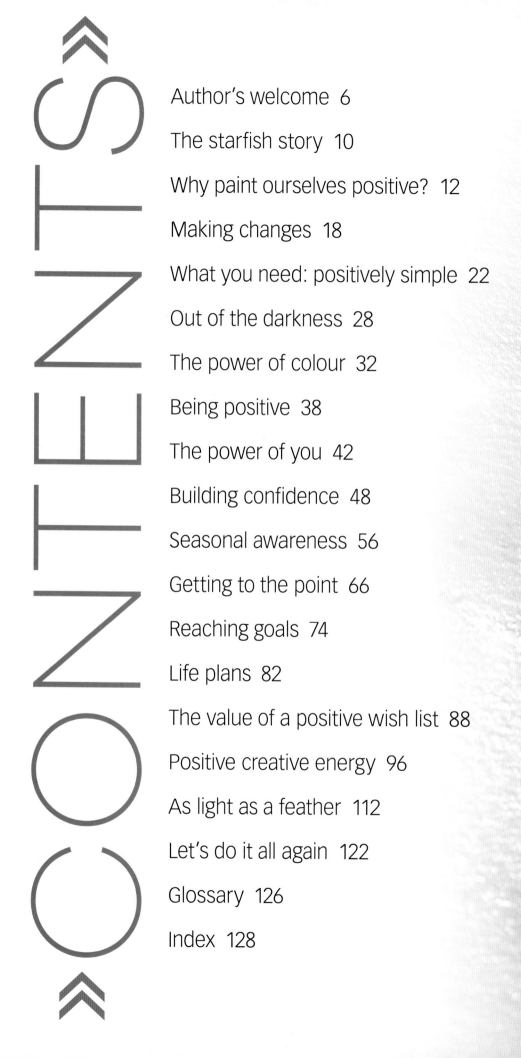

CONTENTS

The starfish story

Welcome to *Paint Yourself Positive*, a book that I hope will help make a difference to your life in a truly inspirational way. Let me begin by telling you a well-known story I once heard. Whether it is folklore or true, this tale has been shared all over the world; and although the characters in it are often varied by the storyteller, the message it holds remains the same.

Picture the scene: you are standing on a beautiful beach with clear blue skies above you, white sands ahead of you and under your bare feet. When you listen, you can hear the sound of the ocean. Bliss.

While on vacation, a tourist is wandering along what he thinks is a deserted beach when he notices hundreds of small objects scattered in the distance. As he draws nearer, he can see that these objects along the shoreline are in fact hundreds of starfish that have been stranded by the tide. He notices a young local picking them up, one by one, and gently returning them to the sea.

As the tourist approaches, he congratulates the young man on his kind intentions, which clearly won't make a difference to the situation; then goes on to explain that there are far too many starfish to save and that there isn't enough time to rescue them all. He tells the youth that his efforts are a waste of time, as he can't possibly make a difference to all the stranded sea creatures scattered over the beach.

The young local stops what he is doing for a brief moment and looks at the tourist thoughtfully. He then bends forward, gently picks up a starfish and throws it skillfully back into the sea. He smiles broadly as he looks back at the puzzled tourist and replies, 'I made a difference to that one', and of course he did.

We all have the ability to make a difference if we think positively, and that is what this book is about. Approaching life, tasks and challenges with an attitude that will lift our spirits and help us overcome negativity that can drain our souls.

A new way of living is about to begin. Purely by painting yourself positive.

Welcome to my new book.

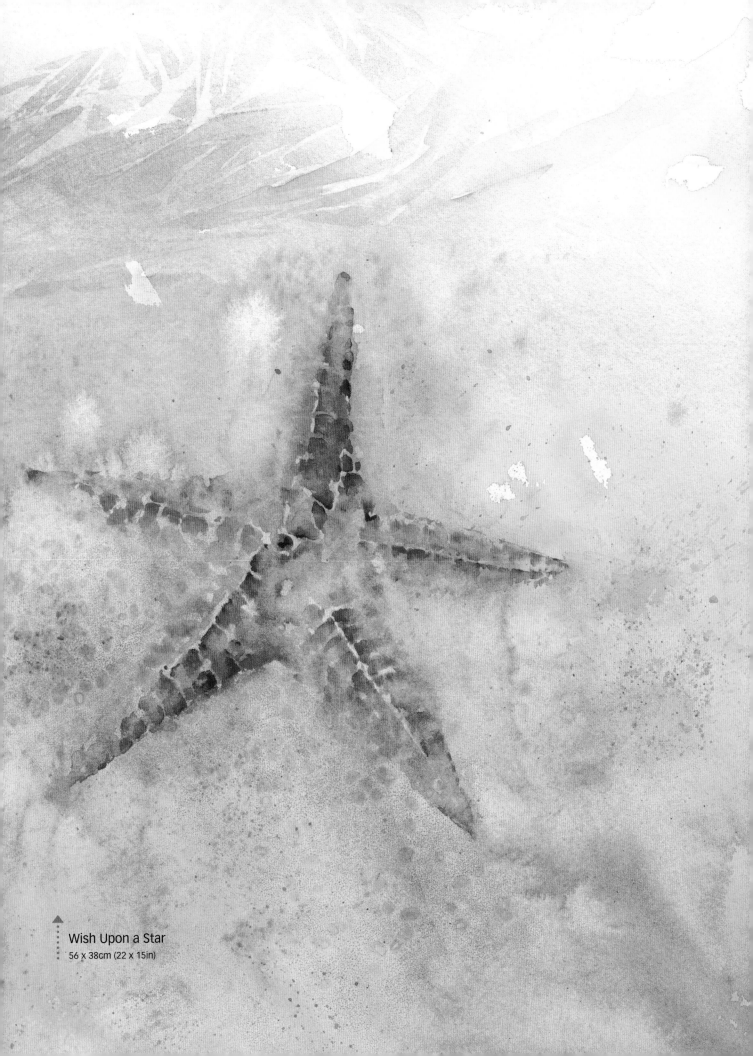

Wish Upon a Star
56 x 38cm (22 x 15in)

Why paint ourselves positive?

Through the simple act of painting regularly, you can achieve a state of positivity that can help you live your life more confidently, with increased happiness, and with more energy.

Improving our lives

It is with conviction that I write that painting can change our attitude or help us overcome obstacles in life, because it has helped me personally in many ways, and from teaching internationally, I know that it helps others too. The following pages look at some of the reasons that you should paint.

I continually meet artists or read email messages from people across the world who have read my books, and they all describe their own experiences, telling me how working with colour and painting has helped to improve their lives on so many levels. They say that they feel better about themselves, they deal with problems more easily, they carry less stress and some tell me they feel younger than they have for years. Perhaps that should be the title of another book in the future: *Paint Yourself Young*!

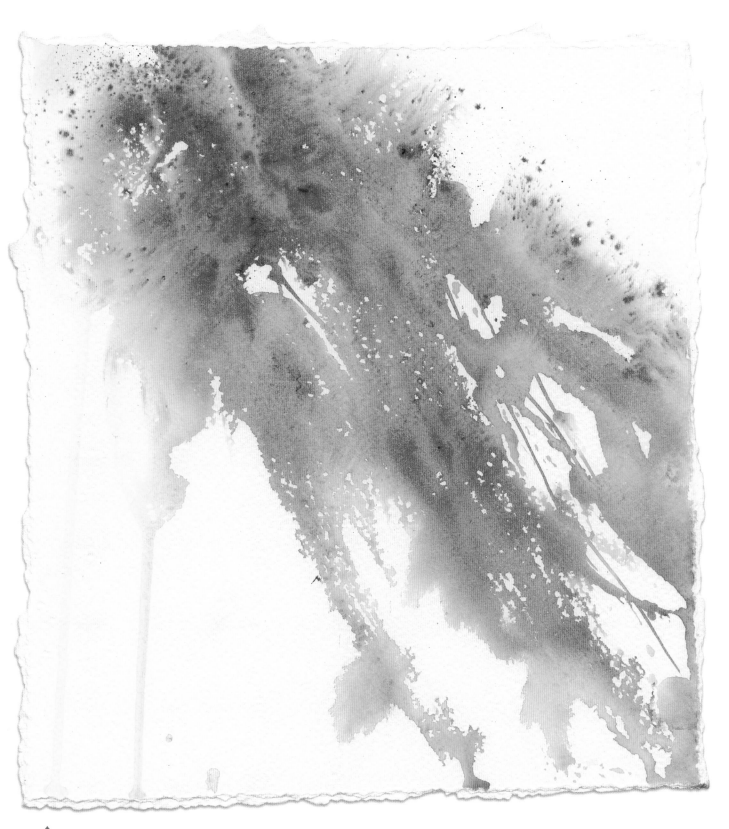

Energizing Colour Flow

38 x 38cm (15 x 15in)

Playful combinations of colour flowing and interacting across paper can bring such a joyful feeling; both during the creative experience and long after it is complete.

Inner strength

Painting can be a therapeutic pastime to help us to relax and feel calmer, and it can also change your life by helping you gain more confidence, achieve a sense of self-worth, and allow you to access the inner courage and strength that you may not have realized you possess.

Painting can also improve your mental attitude to daily issues that may seem out of your control. Such situations can be strongly influenced by how you deal with them and I will be looking at positive ways to do so in the exercises throughout this book. I would like you to reach the last page of this book and think more highly of yourself. This is quite an expectation of pages containing colour and text alone! However, my goal as the author is that you leave my book at that point with a newly found positive attitude that affects every single part of your daily life.

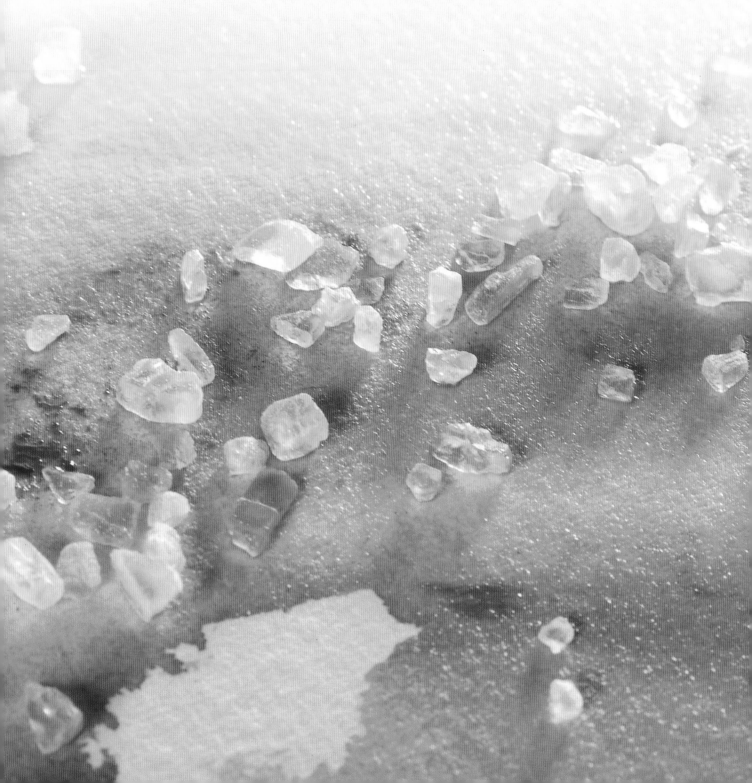

Control

Why do we need to paint ourselves positive in the first place? Perhaps you are a naturally cheerful person, with the ability always to see the bright side of every situation life throws at you; but not many people are.

There are many situations that could really frustrate us, and many things that could make us think negatively. Listening to the news, for example, can often be depressing; our health isn't always what we would wish it to be; the weather can get us down at times, as can negative people, and things can go wrong unexpectedly. Sadly, such things can make us feel out of control, dragging us down or dampening our spirits. That is, if we allow them to!

There is so much that can affect our spirits and who we are on a daily basis. I am not for one minute suggesting that painting can change any of the bad things in life around us, but it can certainly help how we deal with them. At the same time, painting can also improve the quality of our lives: I wake each day energized, feeling fantastic from the colour I have used the day before, and looking forward to creating.

I should explain here that this book isn't about aiming for finished paintings to frame. The goal of each exercise is instead to feel different. To feel wonderful, alive, and able to take on the world as a new you starts to appear.

Affirmation

What this book contains is affirmation that you can think positively; such that you live your life more confidently, with increased happiness, and with more energy to hurl back into enjoying each day, week, month and year ahead.

How we think about things and about ourselves is important.

You are worth caring about.

You are worth the time to enjoy life to the full.

And you can do whatever you want to do if you set your mind to it.

Right now, I would like you to set your mind to painting yourself positive!

Let's go!

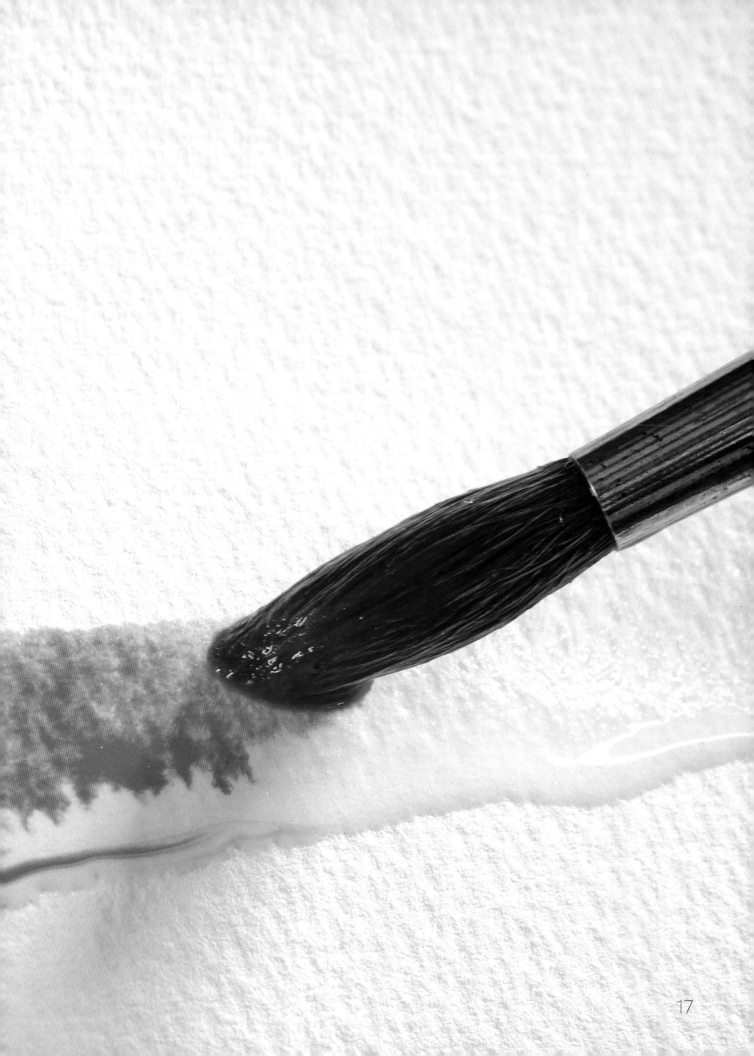

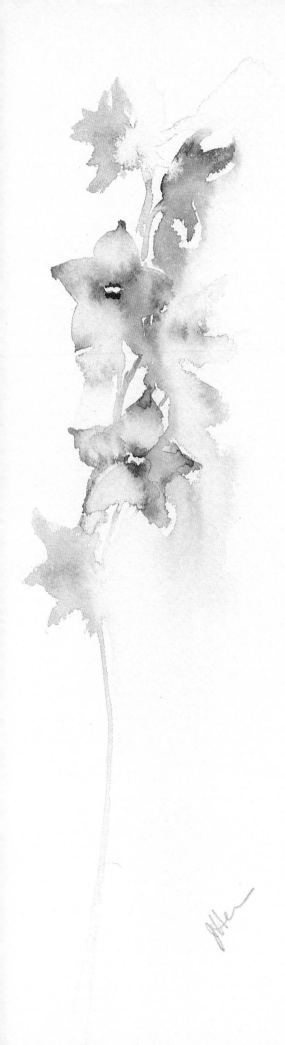

Making changes

Painting regularly can change how you face and deal with a problem.

I would like you to think about yourself and why you are interested in reading a book entitled *Paint Yourself Positive*. The term 'positive' can apply to many aspects of our lives, from thinking to actively doing something. When I started writing this book I felt I was already a confident personality, with very little in life that bothers me or seriously affects me. But who I am now is very different to the personality I used to be.

I started life as an extremely shy youngster who hardly ever spoke, even when talked to. In fact, at my first school my teachers thought I had a speech impediment. I had been brought up in a home where 'children should be seen and not heard', so as a child, I didn't speak up. I can happily say I have now made up for lost time, frequently speaking at art events in front of hundreds of people. How on earth did I get from who I was to who I am today? Where did I gain the confidence, and what made that huge change to my character and personality?

Finding courage...

It may very hard for you to believe this, but it is painting that has given me courage throughout my life. It has been a form of escape when things were frightening, such as when facing a cancer scare. It has helped me make friends through art classes that I have joined over the years. It has increased my confidence in so many ways, so that I no longer approach a challenge thinking 'I can't do it', but consider how I can. If I can change myself through painting, then you definitely can.

Painting is like an old friend I can turn to if ever I feel low. Wherever I am, and no matter what is happening, I can always turn to my brushes and favourite colours.

...losing fear

Painting regularly can change how you face and deal with a problem. In my case, shyness and the inability to try new things because I was scared hindered my early years.

Helping you to deal with fears is one way painting positively can aid you. Are there any fears you would like to overcome, or challenges you need to face to improve your life?

Recognizing your weaknesses

If I can get to where I am now through painting alone, you can too. I knew what my weaknesses were; and still are. I was shy. I couldn't say boo to a goose.

Having been brought up frequently being told what I couldn't do, rather than any focus being placed on what I could, I had no self-confidence. I thought that I was useless. But I know now that I am not! I was scared of everything. Flying, driving… seriously, listing what my fears included is quite amazing; anyone who has ever met me would not believe it. I have overcome all these problems by painting; and you can too. You can overcome anything that you are facing or don't like about yourself by being open, right now, to yourself.

Taking control

Creating brings a sense of control. Even something as simple as choosing what colours you want to use, and how you are going to use them, offers you control. I am going to show you how choosing the right colours and techniques can do so much for your outlook on your life and sense of well-being.

Honesty

To begin, make a mental list of things you wish you could change about yourself and your life. If you could make just one change for the better, no matter what it is, I hope my book will help you to achieve it.

Before we start painting ourselves positive I would like you to get ready by making sure that you have the right equipment to use. You don't need much, just a few items will get you started.

To face your new adventure, turn the page!

Positive Energy

28 x 33cm (11 x 13in)

Colour alone can change our mood, and painting can be a very simple way to achieve a healthy positive attitude.

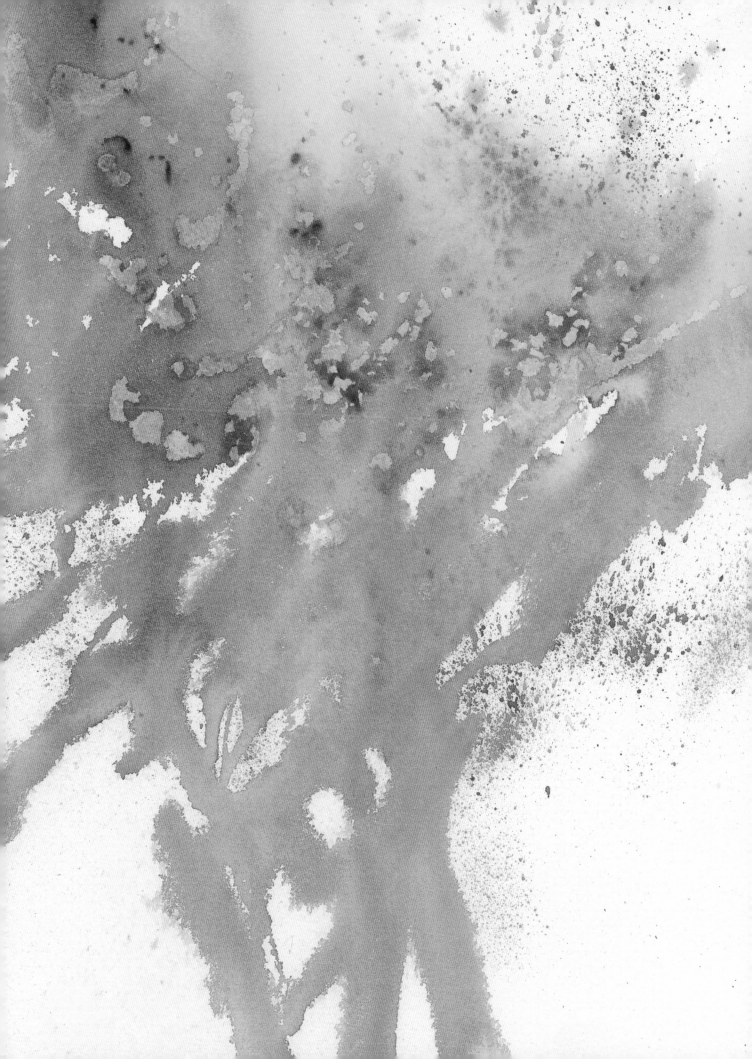

What you need: positively simple

'Once you replace negative thoughts with positive ones, you'll start having positive results' Willie Nelson

This is a very different type of art book from the others I have written. It is based on how we feel when we paint and after we have painted. The main aim of this book is for you to create in a way that you find pleasing, improves your mood and leaves you feeling energized. Because there are no set goals to achieve, you shouldn't carry any negative feelings of self-doubt before picking up a brush such as, 'Am I good enough to paint?' or 'Can I even do the exercises in this book?'

In any case, I can answer both questions immediately:

'Yes, you are', and 'Yes!'

You really can do everything in this book. No matter who you are, or whether you can already paint or not, It was written with you in mind. Self-worth, increased self-confidence, a sense of power and control, the freedom of letting go, the ability of being able to look ahead with joy. So many wonderfully positive things can come from reading this book. Like many things in life, art can quickly become overcomplicated, so I will be keeping everything very simple to begin with. All you really need is paper, a few tubes of watercolour pigments and one or two brushes.

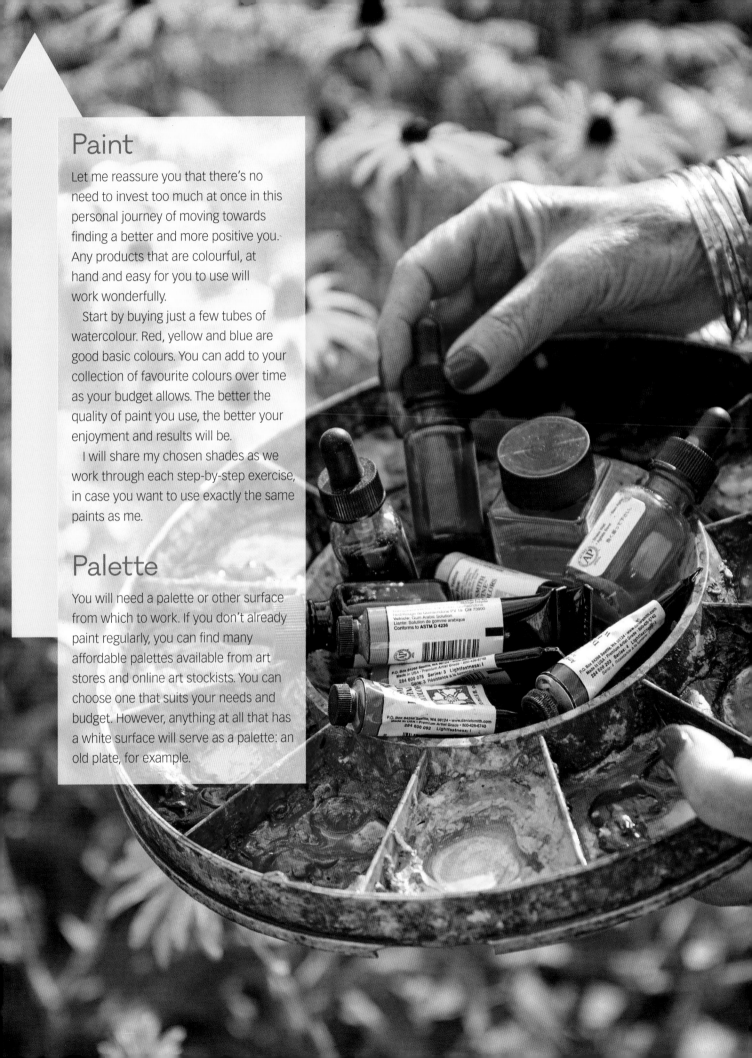

Paint

Let me reassure you that there's no need to invest too much at once in this personal journey of moving towards finding a better and more positive you. Any products that are colourful, at hand and easy for you to use will work wonderfully.

Start by buying just a few tubes of watercolour. Red, yellow and blue are good basic colours. You can add to your collection of favourite colours over time as your budget allows. The better the quality of paint you use, the better your enjoyment and results will be.

I will share my chosen shades as we work through each step-by-step exercise, in case you want to use exactly the same paints as me.

Palette

You will need a palette or other surface from which to work. If you don't already paint regularly, you can find many affordable palettes available from art stores and online art stockists. You can choose one that suits your needs and budget. However, anything at all that has a white surface will serve as a palette: an old plate, for example.

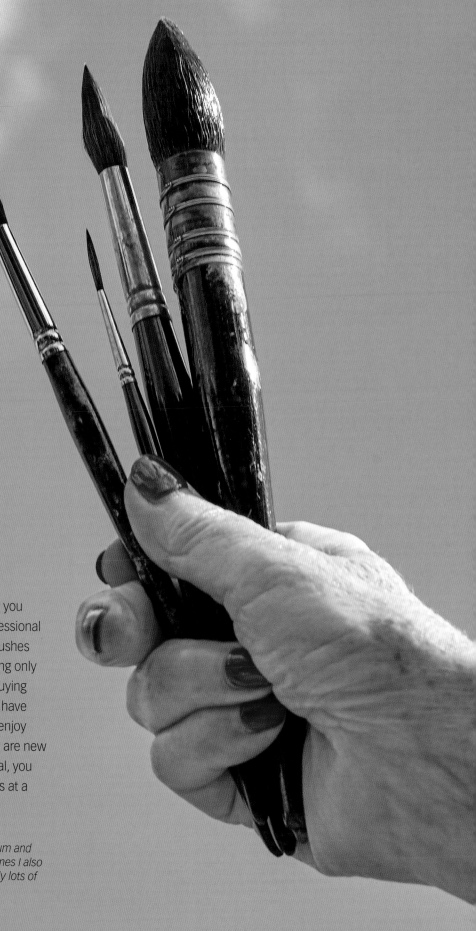

Brushes

Two or three watercolour brushes are all you need. For the sake of their career, a professional artist needs and uses the best quality brushes that money can buy, but if you are painting only as a hobby or to experiment, I suggest buying more affordable brushes. As long as you have tools to create and enjoy using, you will enjoy the following sections in this book. If you are new to painting and find this book inspirational, you can always invest in some better brushes at a later stage.

I generally use just three brushes: large, medium and small – a size 14, size 12, and a rigger. Sometimes I also use a very large mop brush – generally to apply lots of water. All four are shown here.

Paper

You will need lots of paper. The weight of the paper is important because if it is too thin, you will find it buckles when water and colour flow over it. Try experimenting with watercolour paper in different weights but avoid buying any that is less than 300gsm (140lb) in weight.

You will also find watercolour paper comes with varying surfaces, from smooth to extra rough. I like a rough surface paper as it gives such gorgeous effects. You will see these in my demonstrations and paintings throughout the book.

Water container

You can use anything! An old bowl or a chipped mug will be perfect. You can use anything at all to work with and clean your brushes, as long as it can hold water.

Optional additions

There are many other items that can greatly enhance our creative sessions. For example, we can use many aids to form texture in our work such as a variety of **salts** in different granule sizes; **plastic food wrap**, straight from the box or pre-used; white **gouache** for adding light or white sections when needed. **Kitchen paper** is useful for lifting or removing colour, and a **toothbrush** for splattering colour is fun too.

You will see a few other items mentioned in this book such as **granulation fluid** which can be purchased online or from art stores; an empty clean **spray bottle** to use with water; **gold watercolour powder** for adding glittery effects; and a **wax candle** for invisible wax writing.

I will explain how to use all of these things in the demonstrations that follow, but this list is purely a starting point of ideas for you to grow from. There are many more; indeed, you may stumble across your own exciting new material to try!

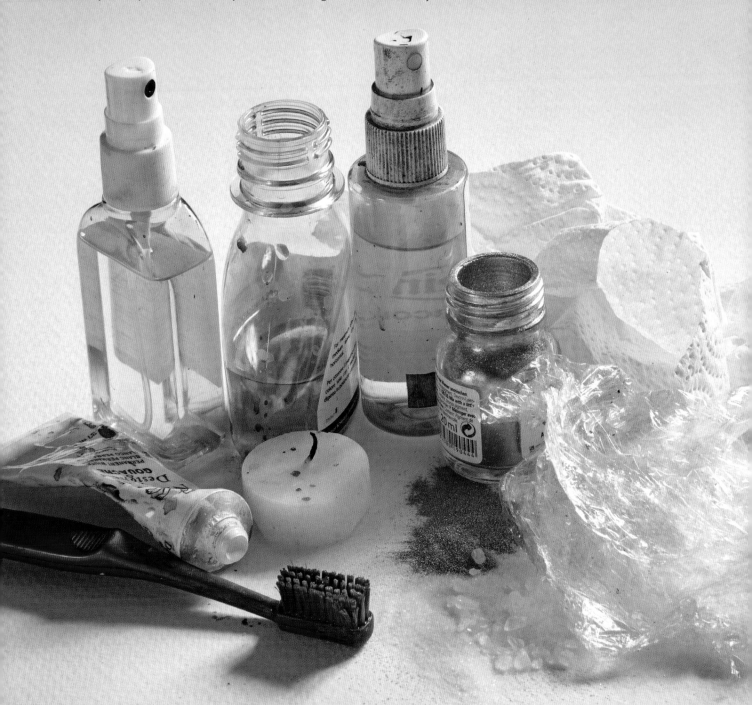

Time

Set yourself the goal of painting a few times a week. Just like going to a yoga class or other weekly event; begin by making a schedule to fit in a few periods just for you; time to paint and think. Make time to be positive so your painting exercises will have a greater benefit and effect.

Space

You need a quiet area to zone in on when you move your brushes. Try to find a space where you won't be disturbed by noise, so you can focus solely on what is happening while you are creating. You will need to think about what is happening as colour flows, and to do this you need to be in an area where you can connect with anything that happens during your creative session.

Please remember: in the exercises that follow, we are not aiming for perfect paintings that are going to be framed or hung in a gallery. As wonderful as that may sound, that form of painting can sometimes carry a sense of having to achieve. Following that train of thought is not what this book is intended for.

I won't dismiss the fact that this book could help you become a better or more enthusiastic artist; or encourage you to take up painting if you are new to the idea of creating. In fact, this book could very well lead you forwards to a fabulous artistic journey if you enjoy doing the exercises and demonstrations it contains. That alone would be a positive outcome from reading this publication.

However, right now we are only looking at how the process of painting, rather than the results, can affect us.

'Attitudes are contagious.
Is yours worth catching?' Anon.

Out of the darkness

A life without colour

Imagine a world with no vibrant colour. Think of everything you see, from grass to sea, as utterly devoid of any hue beyond grey and black. In your mind, go for a walk through fields of dark grasses and imagine the trees in the distance. Think how life would be if this were what you faced every single day – and yet we often ignore how important colour is to our lives.

In the same way that painting with black alone can feel dark and depressing, bringing with it a sense of negative energy, creating using a variety of colourful shades can lead to a sense of well-being and a feeling of positive energy.

Colour research has shown that the colour yellow makes many people feel happy, while those who are suffering from depression or anxiety tend to opt for grey or black shades. Being happy and stress-free can improve our health, state of mind and in turn aid our quality of life. We can't always feel happy but wouldn't it be wonderful if we could? In this section we are looking at grey days, problems and moving away from them.

Before we begin the colourful exercises that follow in this book I would like you to work in one colour: black. This may seem surprising, given what I have just said, but this is for two reasons. Firstly, because it is simple to do so; secondly, because comparing how we feel when working with colour after having painted with black alone for a while is quite amazing. This is effective at changing our attitude and lifting our spirits.

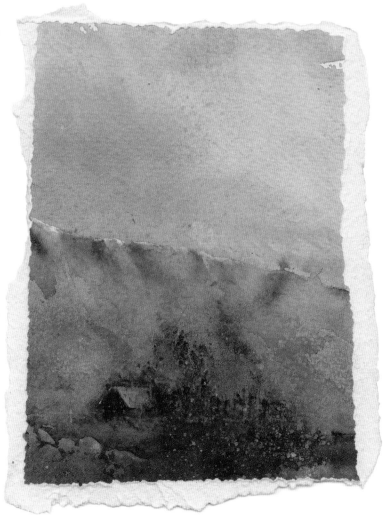

Lull Before the Storm
15 x 20cm (6 x 8in)
Welsh cottage scene.

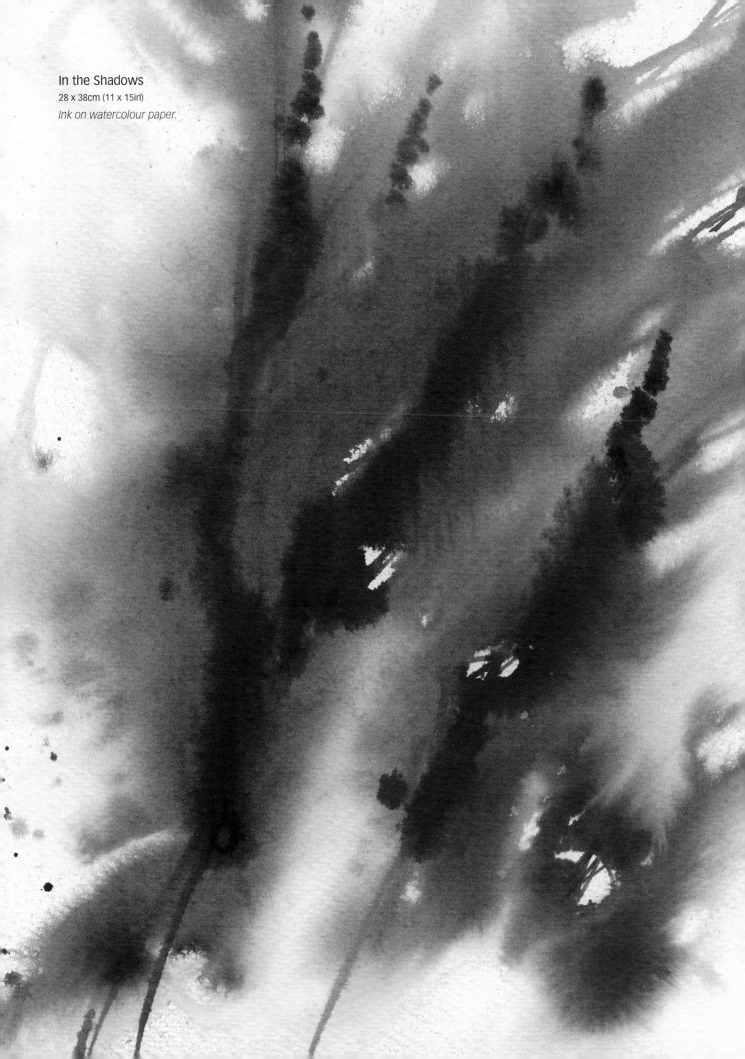

In the Shadows
28 x 38cm (11 x 15in)
Ink on watercolour paper.

» Seeing the light

This is such a simple exercise and so enjoyable to carry out. You just need one piece of paper, one brush and some black ink. With the addition of water alone, we are going to make patterns with it. The goal is to gain the feeling of release when we later work with more colourful shades; to let go of all negativity by leaping from darkness into bright light.

Your goal here is to leave as much white paper as possible to represent light and happiness. Make a mental note not to cover the whole paper with colour. To leave the majority of the paper surface white when creating can be a difficult achievement for some artists who paint regularly.

We are going to form a simple effect, step by step. Think of three problems that you would like to disappear, or three things you would like to change about yourself. The three ink spots in this demonstration represents these. As we progress through the book, you will hopefully find these problems gradually becoming less important or easier to deal with.

What you need

▸ A scrap of clean white paper

▸ A tube of black ink or watercolour paint

▸ A brush and clean water – a Chinese calligraphy brush is ideal, but any any brush will do

1 Put your brush into clean water and then make three wet circles on your paper. Perhaps make them different sizes, to represent the priority of things you would like to change.

2 Now touch the centre of each wet circle with the dropper of the ink. Quickly pull the dropper away and watch as the ink moves into the wet space. This action can be quite beautiful to watch: the interaction between ink and water is mesmerizing. Please don't be tempted to go back in with your brush once the ink has been applied. Just allow it to move and dry naturally.

As you add the ink to each new wet area, take time to watch what happens. The sense of fascination and the thrill of seeing magic happen on paper often leaves us feeling exhilarated when creating, and long after we have put our brushes down.

Don't race your painting exercises. Really take time to enjoy them and gain from them inwardly.

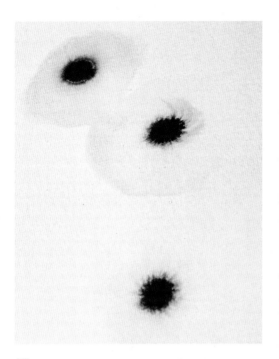

3 Repeat the process with the two other wet circles and leave to dry. Before you add the ink each time, think of it as symbolic of negativity. As you drop the black colour, note how it moves.

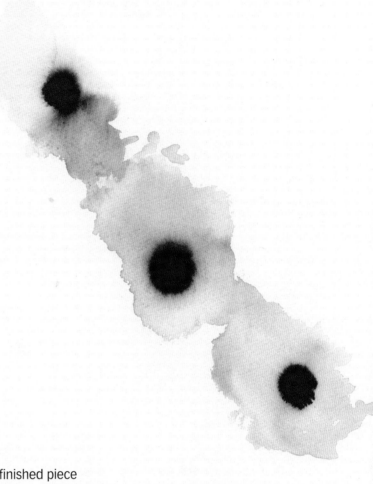

▲
The finished piece
28 x 38cm (11 x 15in)
Imaginary flowers created simply from three black central ink spots.

TIP

Bear in mind that learning a new activity or art technique isn't always easy to pick up straight away. However, with a little time and regular practice, your creative time will become a more enjoyable, refreshing and positive experience.

Just as it is hard to control our negative thoughts, it is hard to control black ink on wet paper. However, if we use less colour and cover less paper with the black shade, it can look beautiful. Perhaps not as beautiful as if we had used colour, but better than covering a piece of paper with black in the same tone. If we look at using black colour in this more positive way, we are making it work to overcome negativity, and turning a negative into a positive. We are gaining control. We are creating.

The moral of this exercise is to try always to see the light. Try to leave white paper and see it as a symbol of hope, of things getting better and brighter.

When you are feeling down, I highly recommend using bright cheerful colours to paint with to lift your mood. But every once in a while, take your colours away and just work in monochrome shades of black or brown. When you use your bright colours again, your mood will be instantly uplifted.

We will now be moving on to using fabulous colours, and learning how creating with them can make us feel far more positive.

'Art washes away from the soul the dust of everyday life.'

Pablo Picasso

The power of colour

'To create one's own world takes courage.' Georgia O'Keeffe

The effect that colour has on us is simply astonishing. Depending on the shade we opt for; and whether we wear it, surround ourselves with it at home or use it to create with, colour can cheer us, or quieten us.

I find colour especially useful for energizing myself. Painting with vibrant glowing shades like bright red, for example, is soul-lifting. It can help us feel more positive and ready to face what life may throw at us. If you think about the darkness of the paintings on the previous pages and then observe the brightness in the piece shared here, the difference is quite staggering.

Painting should be fun and something to look forward to. At the same time, creating can also drastically change how we feel. I am now going to show a simple step-by-step exercise so you can start painting with colour.

33

Traffic lights

Think of traffic lights and what each colour means. Red represents stopping. Link this colour to blocking any negative thoughts or influences in your life. Amber represents a pause, giving you time to prepare for your next action or decision. Link this colour with thinking about what you need to do in the future to enhance your life. Finally, green represents go: moving forward safely, with excitement or sheer joy at what the future holds.

For this exercise, paint each of these three colours using a strength of shade that reflects your own personal associations with these meanings. Each time you carry out these washes, try playing with the colours, making one more intense than the others depending on what you need from it.

You can try using different reds, greens or gold shades for variety, or using different techniques to add texture to them for interest. Below are a few ideas.

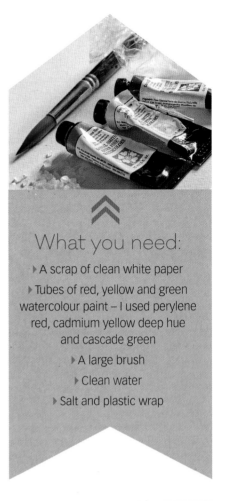

What you need:

▸ A scrap of clean white paper
▸ Tubes of red, yellow and green watercolour paint – I used perylene red, cadmium yellow deep hue and cascade green
▸ A large brush
▸ Clean water
▸ Salt and plastic wrap

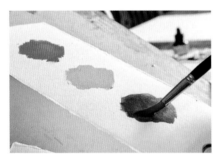

1 Painting three simple circles with the positive traffic light colours can give you clean effects, and help you think about what each colour represents.

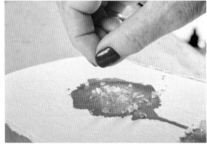

2 You can make the circles of colour more interesting by achieving texture effects with the addition of salt for example. While the colour is still wet, sprinkle a little salt on the colour surface and leave it to completely dry.

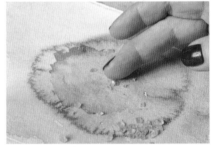

3 When dry, use your finger to remove the salt and see the pattern that has emerged.

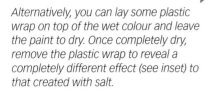

Alternatively, you can lay some plastic wrap on top of the wet colour and leave the paint to dry. Once completely dry, remove the plastic wrap to reveal a completely different effect (see inset) to that created with salt.

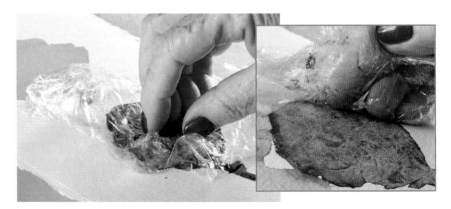

Merging positive lights

Try painting the three traffic light colours on one piece of paper and allow them to merge together as shown here. You can experiment by using plastic wrap or salt to add texture on your merging positive traffic light washes.

Life often appears complex and confusing, with no time to disentangle what we would like to change. Painting these colours can give us time to work out what we need to do in our lives to move forward more positively.

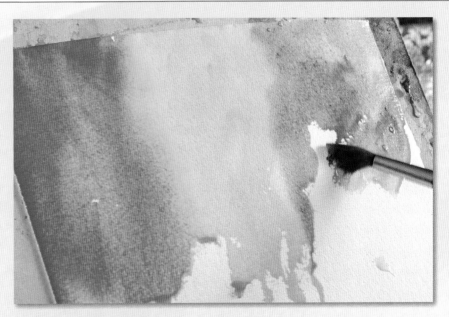

Try again

Once you have completed these exercises, look to make changes to what is happening in your life; then try these traffic light exercises again, with different, more positive, outcomes each time.

Paint this exercise regularly and try to reach a point where you can paint the negative problems in paler and paler shades of red. Focus on getting to the point that you can paint the green as the strongest, most positive colour.

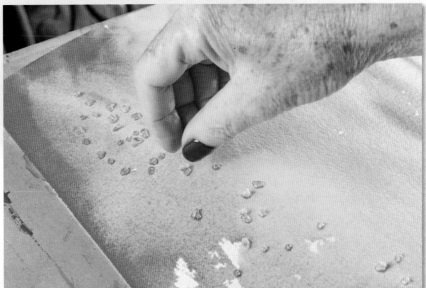

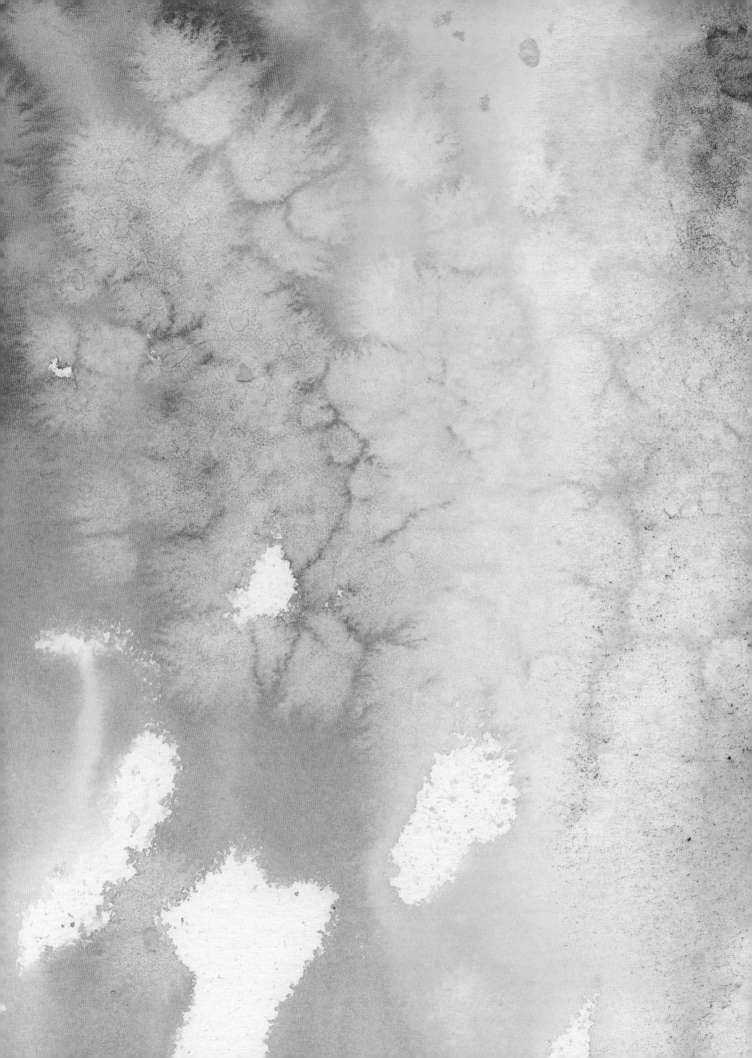

Colour has power: use it well!

Perhaps you need to be more actively positive, in which case your focus should lie with the green shade. If, on the other hand, you are feeling too negative, try working with red as a reminder to help you stop doing so.

Use colour to change your mood, strengthen your resolve and aid you in your life journey.

Positive negatives

For the next exercise you will only be using one colour: red. This represents all that you need to stop or take control of in your life. Use it to energize yourself in a positive way, by working out how you can improve the quality of things you enjoy.

When composing a painting, negatives do have importance. They highlight what is worth seeing, drawing attention to it. Using negative space in a painting can make the beautiful sections look much better.

Focus more on what you like in life and less on what you don't. Become actively positive in thinking, and avoid dwelling on negatives.

The finished piece
28 x 28cm (11 x 11in)

Traffic light colours allowed to merge on one piece of paper. Salt was placed on top of the still-damp wash to create this interesting pattern. The salt was removed once the paper was completely dry.

Being positive

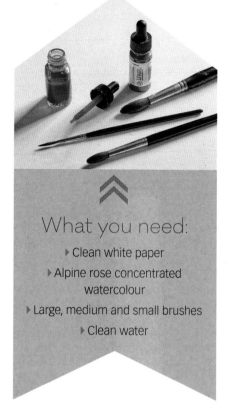

›› Positive flow

As you start this painting exercise, I would like you to bear in mind that you are in control of what happens. You have the power to make colour flow or stop flowing; and by working in red, you will be absorbing the powerful energy of the colour you are using.

What you need:

› Clean white paper
› Alpine rose concentrated watercolour
› Large, medium and small brushes
› Clean water

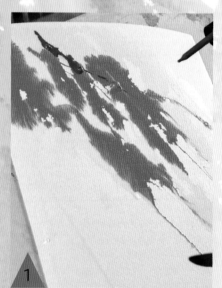

1

2

3

1 Place your paper at an angle by leaning it on a board of some kind. Anything will do; even a kitchen tray propped up on something is perfect. Wet your paper with clean water in a diagonal pattern from one corner at the top of the paper to the opposite lower corner. Pick up red colour from your palette and add it to the freshly wet paper. Watch as the colour flows into the wet area. This can be really fascinating to observe.

2 Watercolour pigment looks different when it is dry: the finished effect will be paler. If you feel your colour looks too pale at this first stage, add more red now. Try to avoid covering all of the white paper. Leaving some white gaps of paper will breathe air, energy and life into your wash.

3 While the colour is still wet, take a very fine brush and drag the still-wet colour through the white segments of paper. These fine lines create a connection between one block of colour and the next. They aid the directional energy flow and they bring a source of energy into your work. They also add great visual interest and positive contrast.

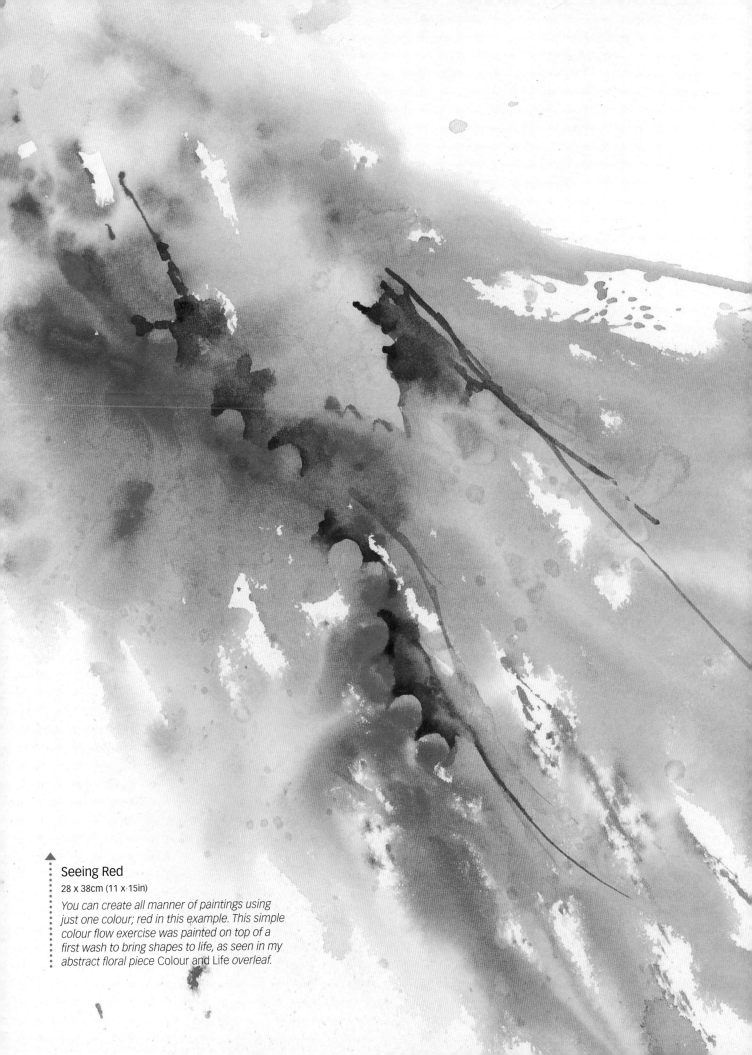

Seeing Red
28 x 38cm (11 x 15in)

You can create all manner of paintings using just one colour; red in this example. This simple colour flow exercise was painted on top of a first wash to bring shapes to life, as seen in my abstract floral piece Colour and Life *overleaf.*

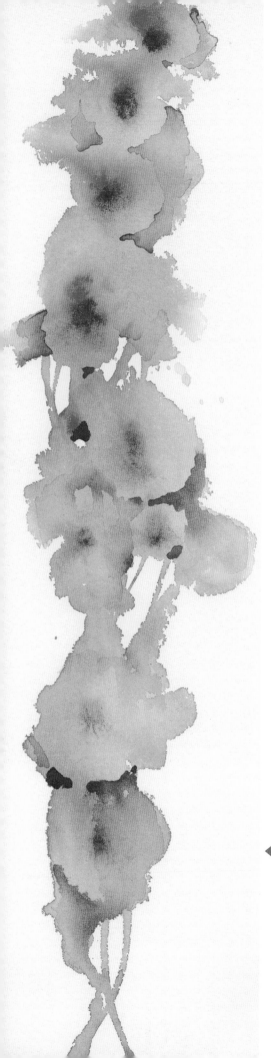

Centre focus

Following on from the colour flow exercise on the previous pages, take a narrow piece of paper and wet a central area from the top to the bottom of the paper. With your paper at an angle, repeat the first stages and allow red colour to flow from the top of the paper to the bottom. As before, you can add more colour if you feel it is too pale, but this time, try to be bold and get the strength of the colour right in just one wash.

Repeat this exercise, getting stronger and stronger with your colour application each time. Feel positive before you start painting, and look forward to knowing what is going to happen each time you paint. Over time you will build up your confidence, and this is a wonderful boost to both your energy levels and also how you approach other things in life.

When this first wash is dry, you can add centres for imaginary flowers and a few outer edges to bring shapes to life in a way that pleases you. In the example to the left, I have used circular shapes, adding darker red behind pale flowers. Simple, effective and fun to create.

Sometimes these exercises look truly beautiful because of their simplicity, which raises another point. In art and in life, we often over-complicate things. Find a way to simplify each new challenge you are faced with. It often becomes less stressful and easier to manage when you do so.

Once you have mastered the techniques in these exercises, you can also look at ways to use them in larger more developed paintings. For now, we are deliberately keeping things simple and enjoying the creative process.

◀ · · · · · · · · · · · · · · · ·
Central Focus
19 x 38cm (7½ x 15in)
Abstract floral work.

Colour and Life
38 x 27cm (15 x 10½in)
Abstract colour combinations representing positive energy flow.

The power of you

'There is little difference in people, but that little difference makes a big difference. The little difference is attitude. The big difference is whether it is positive or negative.' W. Clement Stone

You are unique, an original. There is no-one else in the world like you. And that is quite a powerful thought. Only you can be you. This is why it is important that you make your own decisions in life.

Art gives me the courage to rely on my own decisions. It has aided me over the years to understand what works in my paintings and why. I have come to trust my instincts.

I have had to find my personal style in painting. Despite the hurdles I have had to face, over the years I have evolved not only as an artist but as a human being too, learning mainly from the progress I have made in my form of creating. Painting is a daily routine that acts as a form of energizing positive therapy.

In art, we all start out as beginners. We may be born with natural talent, but for many people painting is a skill at which they gradually improve. I can relate this knowledge to life: we start out as babies and are influenced by many things as we grow into our adult lives. We can be scarred by bad experiences, too; but we must learn to let go of these or they can badly affect our futures.

We should hold on to everything we can attribute to positive influences, in order to make the best of ourselves in every possible way. A positive attitude gives us power, which is why this chapter is called 'The power of you'.

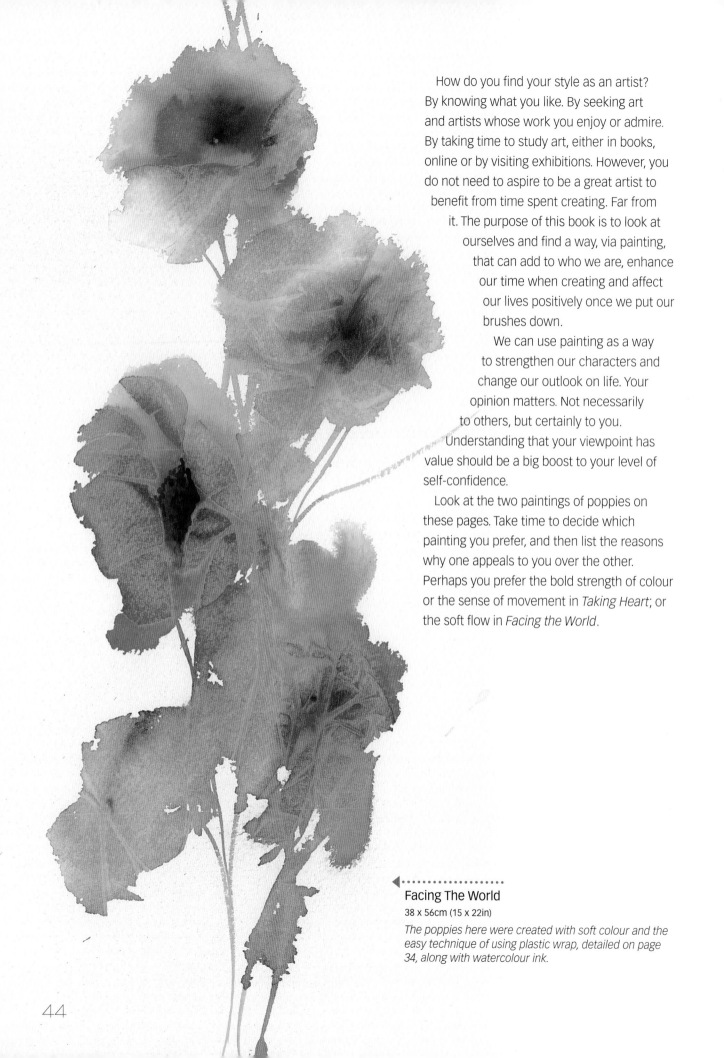

How do you find your style as an artist? By knowing what you like. By seeking art and artists whose work you enjoy or admire. By taking time to study art, either in books, online or by visiting exhibitions. However, you do not need to aspire to be a great artist to benefit from time spent creating. Far from it. The purpose of this book is to look at ourselves and find a way, via painting, that can add to who we are, enhance our time when creating and affect our lives positively once we put our brushes down.

We can use painting as a way to strengthen our characters and change our outlook on life. Your opinion matters. Not necessarily to others, but certainly to you. Understanding that your viewpoint has value should be a big boost to your level of self-confidence.

Look at the two paintings of poppies on these pages. Take time to decide which painting you prefer, and then list the reasons why one appeals to you over the other. Perhaps you prefer the bold strength of colour or the sense of movement in *Taking Heart*; or the soft flow in *Facing the World*.

Facing The World

38 x 56cm (15 x 22in)

The poppies here were created with soft colour and the easy technique of using plastic wrap, detailed on page 34, along with watercolour ink.

I chose the titles because painting in red for me has always felt like taking hold of courage in both hands; feeling as though I can face any problem or take on the world when I do, which is such a fabulous feeling.

Please take note. There is no right or wrong in art. There can simply be enjoyment. That is the most important point to remember when creating.

Now let's paint, using bold red colour to feel energized and positive. Remember also that there is no such thing as 'I can't'.

Only an 'I can' attitude will lead you on to great things.

Taking Heart
38 x 56cm (15 x 22in)

These poppies were created by simply using red watercolour ink and adding a product called granulation fluid while it was wet. This created texture effects.

≫ Poppy

Using a larger piece of watercolour paper will give you more space to allow colour to flow and give you more enjoyment when painting

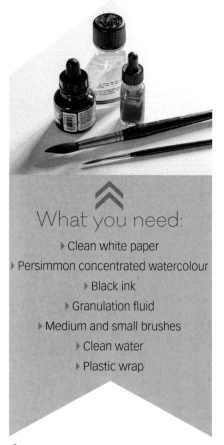

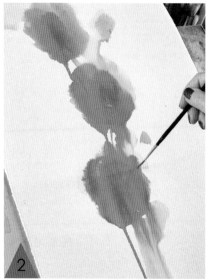

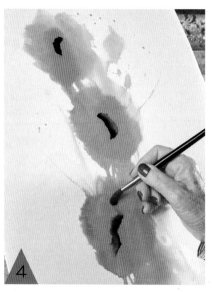

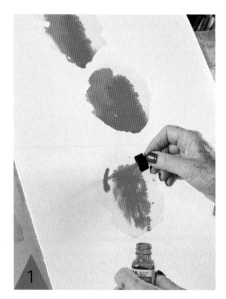

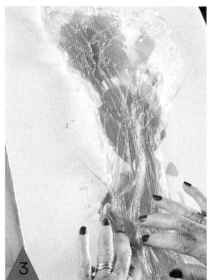

⩓
What you need:

▸ Clean white paper
▸ Persimmon concentrated watercolour
▸ Black ink
▸ Granulation fluid
▸ Medium and small brushes
▸ Clean water
▸ Plastic wrap

1 Place your paper at an angle by leaning it on a board of some kind. Wet three circle shapes on the paper with a clean damp brush and then drop red ink into each wet space. Watch as the ink interacts with the water and enjoy its beauty as it moves and eventually dries.

2 Connect the three circular shapes by using a fine brush to draw colour from each circle as if creating stems from one flower to the next.

3 Before the colour dries, place crinkled plastic wrap over the whole paper and, using your fingers, push it in places to create interesting patterns. Leave it to dry completely.

4 Remove the plastic wrap, then add dark centres with black ink to finish your poppies.

Granulation

If you would like to achieve a looser abstract effect, as seen in my painting Taking Heart (see page 45), follow the same steps but use stronger colour. Instead of laying plastic wrap over the wet paint, add the black centres as soon as you have finished creating the round red circle shapes. While the dark ink is still wet, add a few drops of granulation fluid in each centre section, then wait a few seconds before tilting your paper at a diagonal angle. Allow the fluid to break through the pigment as it flows towards the foot of the paper. Finally, leave your paper flat to dry and add detail to the centres if you would like to.

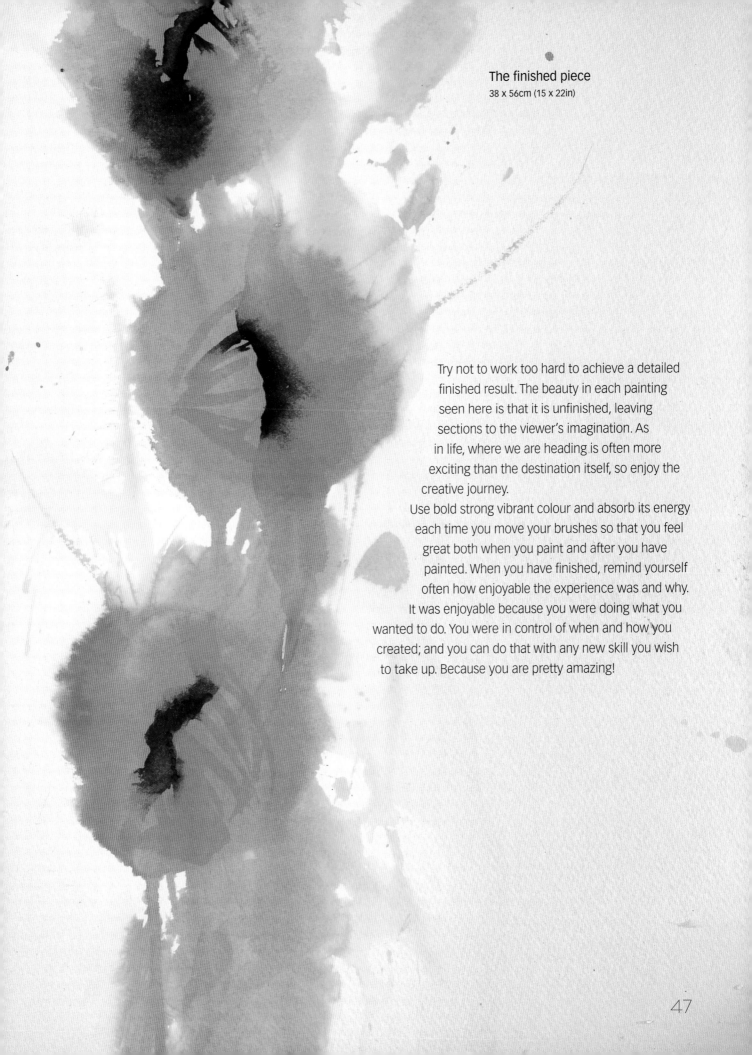

The finished piece
38 x 56cm (15 x 22in)

Try not to work too hard to achieve a detailed finished result. The beauty in each painting seen here is that it is unfinished, leaving sections to the viewer's imagination. As in life, where we are heading is often more exciting than the destination itself, so enjoy the creative journey.
Use bold strong vibrant colour and absorb its energy each time you move your brushes so that you feel great both when you paint and after you have painted. When you have finished, remind yourself often how enjoyable the experience was and why. It was enjoyable because you were doing what you wanted to do. You were in control of when and how you created; and you can do that with any new skill you wish to take up. Because you are pretty amazing!

Building confidence

'Believe you can and you're halfway there.' Theodore Roosevelt

Perhaps the biggest negative factor that can hold us back in life is believing we can't do anything we choose to. There is no doubt that fear, lack of confidence and self-doubt are harmful emotions. Learning to trust ourselves through creativity can be developed as a skill so that we can cope with whatever problems we are facing.

I remember wanting to be an artist from the minute I could first hold a paintbrush, but at first I didn't believe I would become one. Why? Because I thought that so many artists were far better than me. Then I realized that didn't matter, because what really made me happy was actually painting. The process itself, not what others thought of my art.

Later on, I became braver and accepted an offer to exhibit. On the opening night I felt as though I was standing in a room completely naked, for all the world to see. In each painting my soul was exposed. It was a daunting experience. But at the same time, the event was thrilling, and luckily a success.

Had I not taken that first step into saying 'yes', I may never have had the years that have followed, leading me into my own personal and successful art journey. We often say 'no' when asked to do things instead of leaping head-on towards the opportunity that has been offered to us.

Try to say 'yes' more in life, and seek adventure rather than shy away from it. Adventures do not have to be huge. They could simply be trying a new colour to paint with. Enrich your life by doing something new as often as possible.

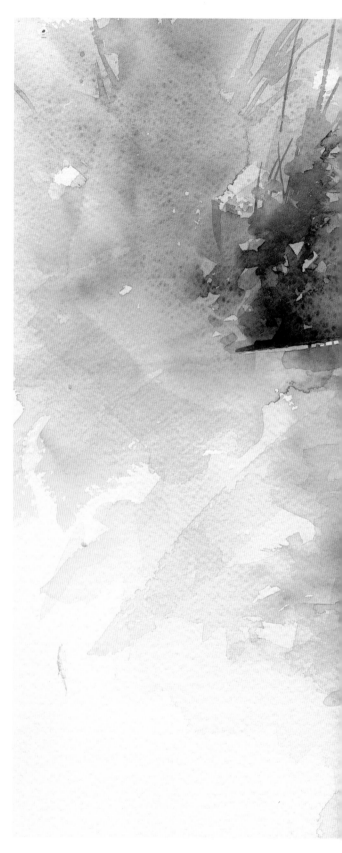

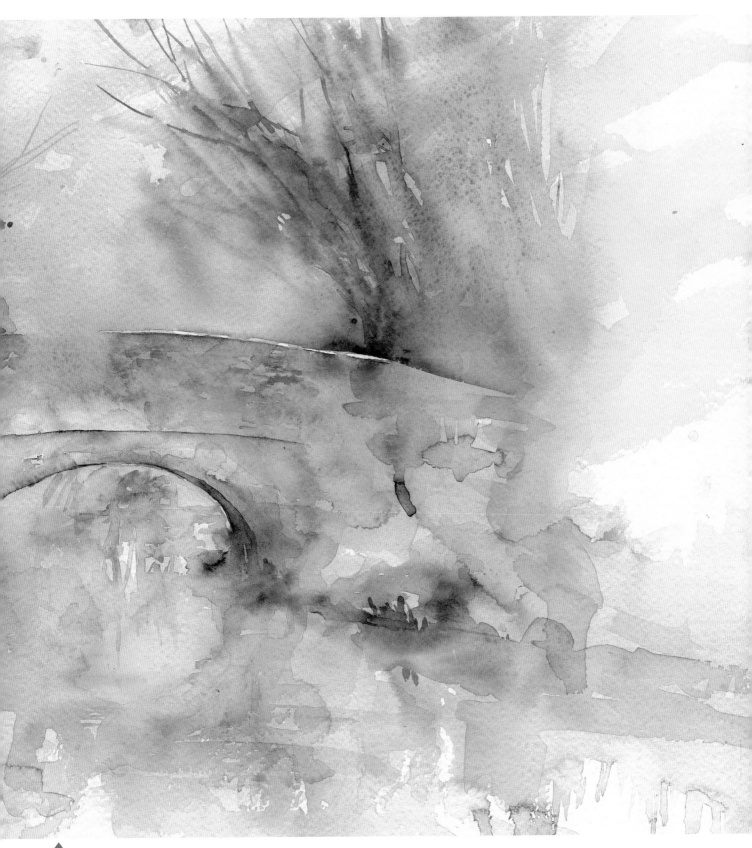

A Special Bridge
56 x 38cm (22 x 15in)

The view from our cottage is of a bridge over the canal. It makes such a beautiful painting in all seasons, but once upon a time I would have been terrified of painting it!

Positive focus

When we are faced with a new problem, we can either run away from it or tackle it. When teaching I have come across many artists who are nervous of painting buildings. They panic because the idea of taking on a complicated challenge can be overwhelming.

In art, as in life, looking for the simplest route to approach something is usually the best way forward. That way you aren't frightened of taking the first step on to what might seem an impossible bridge to cross.

It is a great idea to dismiss all negative thoughts. I love the quote by Theodore Roosevelt that opens this chapter: 'Believe you can and you're halfway there.'

Believe.

Believe that you can do anything and you will get there; perhaps with a little help, but you will. Build your confidence in art by taking small steps to get to where you want to be.

Apply that idea to your life too; taking small steps and simplifying each problem until it becomes an easier challenge to face.

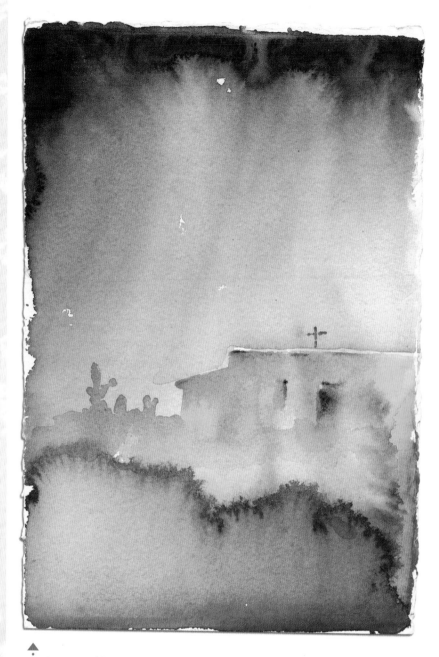

Stormy Skies
19 x 28cm (7½ x 11in)

The dark colour above the building could be a storm approaching or a storm passing. Which would you prefer it to be? How we view things depends on our individual perspective, but I always try to see the best and most cheerful option. I see the storm passing!

> *'Don't let mental blocks control you. Set yourself free. Confront your fear and turn the mental blocks into building blocks.'* Dr Roopleen

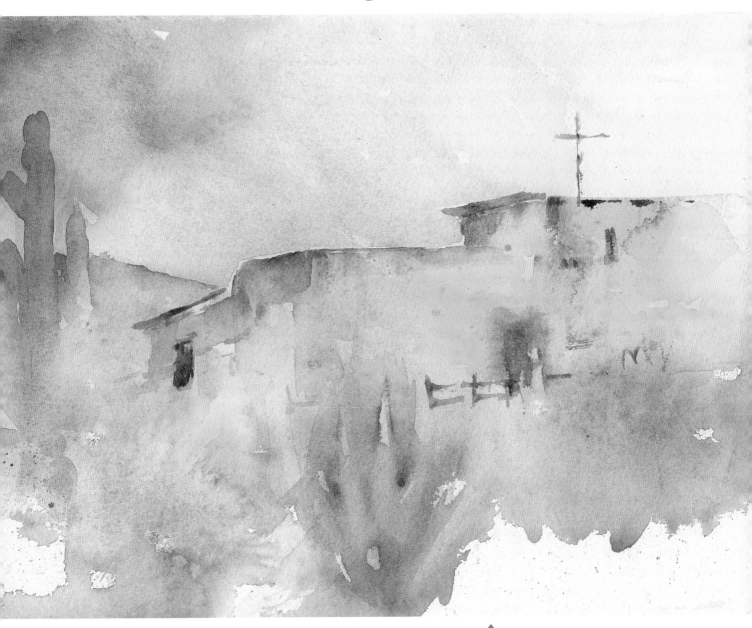

Two views

How we look at something often affects how we think about it; like the glass half-full dilemma: some people see a half-empty glass while others see one that is half-full. When you look at any painting, or situation in life, it can seem easier to see the problems rather than the solutions.

In the next exercise, I'm going to share a simplified way of painting a building. Look at the two landscapes here and decide which one you feel most like painting. The stormy sky or the sunny one? You choose.

Simple Faith
38 x 28cm (15 x 11in)

The tiny cross hints at the dwellers of this building having faith. Sometimes all we need is hope to see us through. Whatever we believe, having the confidence to move forward each day with courage and a cheerful positive attitude is a blessing that should not be denied.

⟫ Simple building

Here you can choose whether you are going to create a stormy sky or a sunny scene, or paint both at the same time!

There are lots of tips in this book on how to use colour, so once you have finished reading it, try returning to this chapter and trying this exercise again in different colourways, or using a variety of new techniques. For now keeping it simple. Begin by creating a first wash by applying colour on paper to form a background to your building.

I used Payne's gray to create a dramatic sky in my stormy scene, *Stormy Skies*, on page 50, and cobalt blue blending into Aussie red gold and cascade green in my sunny scene, *Simple Faith*, on page 51. You can use your own colour choices for your own painting.

What you need:

▸ Clean white paper and scraps of spare paper

▸ A few favourite watercolours – here I used amethyst genuine, cascade green, quinacridone gold, cobalt turquoise, and Aussie red gold

▸ Large, medium and small brushes

▸ Clean water

▸ Old toothbrush

▸ Salt

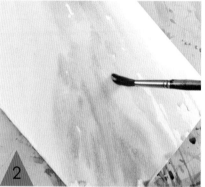

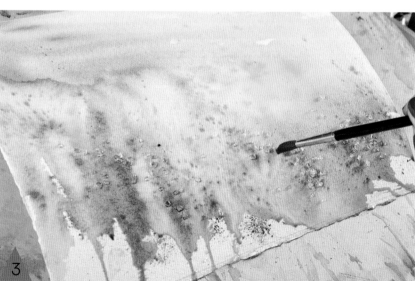

1 Apply a simple sky using your favourite blue shade and water to help the colour flow across the paper. Keep your work at an angle and try to work from one corner of your paper to the opposite corner, letting the colour flow naturally to create a sense of direction.

2 Now apply a colour of your choice in the opposite corner. This will be the foreground section. I am painting a desert scene so I have opted for golden shades but you may wish to use a green shade to represent grass. Experiment and change the scene each time you paint it. These colours are going to act as a simple background to the building.

3 Your background can be as simple or as complicated as you wish it to be. Do remember, though, that if you are painting a subject on top of your wash, always try to keep one area in it quite simple so that your building (or whatever other subject you are painting) will stand out and look beautiful on top of the wash.

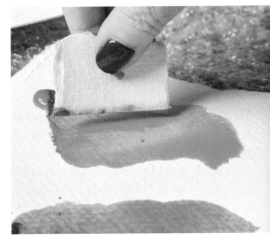

4 Now we are going to use a very fun technique which I find very effective and most enjoyable. We are going to lose the paintbrush and paint with a small spare piece of watercolour paper. If your scrap of paper will not fit in your palette, place some of the colour you want to use for your buildings on a separate scrap of paper. Make these into juicy puddles of colour that are easy to work with; watery but with enough pigment to paint with. Next place a straight edge of the paper scrap directly into the fresh wet colour.

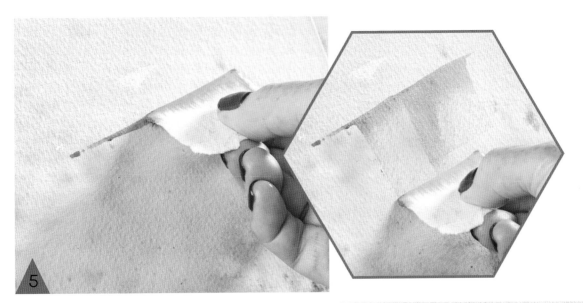

5 Once the previously painted wash has completely dried, place the edge of the scrap of paper where you would like the top edge of your building to be. Pull it along the top outer edge of the building to form a fresh line of colour, then drag this line of colour down (see inset). Alternatively, instead of pulling it down, you can lift the paper away and use the line it has left as your marker for working from.

6 Build up the main buildings with this technique, using colour on your paper to add extra buildings to the initial one. You can place the new coloured line at an angle to form a roof if you wish.

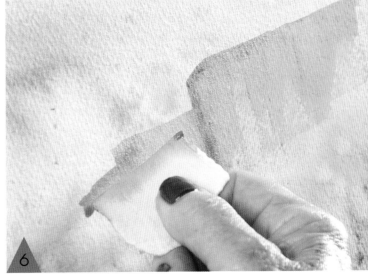

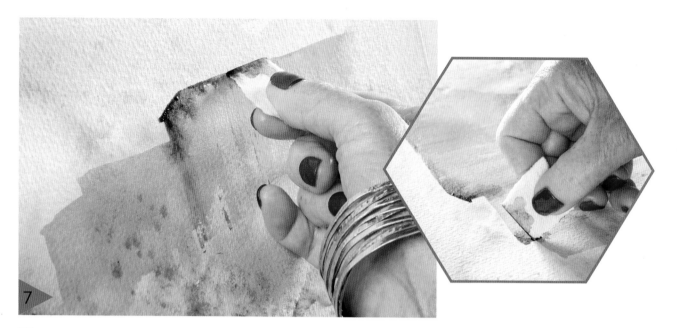

7 There are so many things you can do with this technique. Start looking at buildings and work out how you would paint them but think about each straight line you create as a new adventure.

Practise placing your painting at a side angle. You need to use a certain amount of pressure, gentle but firm, for this technique to work.

Apply your colour boldly and with confidence. You can't be timid. This is a new you. You aren't just painting a building. You are building a new artist and a new beginning too, which is very exciting.

8 Finally when your building is dry you can use tiny little bits of card to pick up pigment to add windows or doors. Of course these little pieces of paper will fit easily into your palette so you can use any colour that you like. As with any new technique, you can get carried away once you have mastered it, so try to keep detail to a minimum. Too many straight lines can look overly fussy, so keep a nice mix. Blocks of colour act as a background. These are things that are unimportant in your life. Put them in the past.

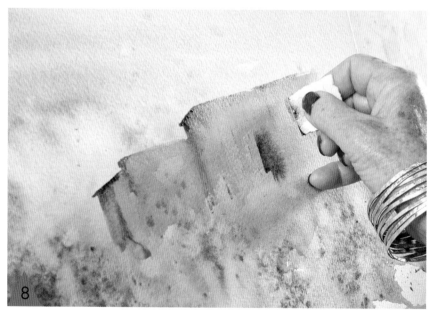

Detail is important to make a painting work. But just enough, not too much. Blocks of colour and a few directional lines make for a successful combination and composition.

Happiness comes from variety and balance. Try to find both in your life and your art. And build on your strengths, recognizing and improving your weaknesses.

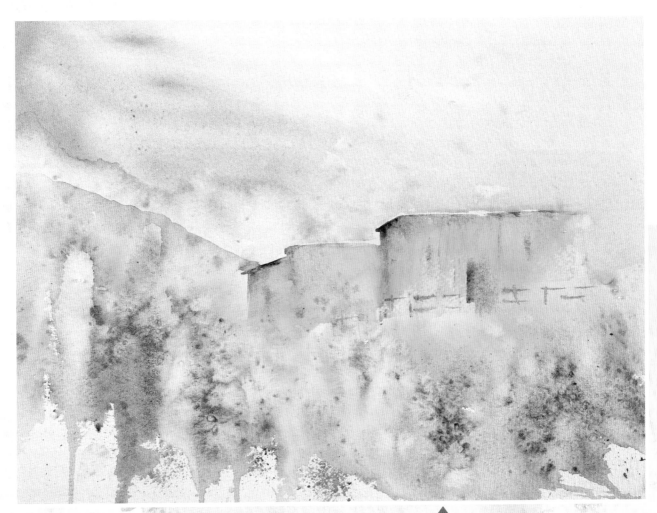

Painting buildings can be simple, once we have worked out a way to approach them. A positive attitude helps us cross so many bridges in life that at first may seem impassable. So when you are faced with what may seem an impossible problem, think twice about how you are going to handle it but believe that you can and will.

The finished piece
38 x 28cm (15 x 11in)

As my painting Simple Faith *(see page 51) was created during my time in Arizona, USA, I have added cacti and a foreground that suited my chosen location. You can do the same, adding whatever you feel is appropriate to your finished piece.*

If you wish to, look at the completed pieces on page 50 and 51 for more ideas on how to take this painting further.

'The moment you doubt whether you can fly, you cease for ever to be able to do it.' J. M. Barrie

Seasonal awareness

'Spring is nature's way of saying, "Let's party!"' Robin Williams

There is a recognized pattern in how the seasons can affect our wellbeing. In some seasons, fewer hours of daylight and dramatic changes in the weather cause long periods without sunshine that can be depressing; in others there are complaints about the constant heat. I try to see the positive in every situation. When we create, we can alleviate any ill-effects of the actual time of year and create positive emotional connections by opting to paint seasons that could improve and lift our mood.

We can learn from each seasonal cycle and benefit from the value in each. Autumn, for example, is a golden time, leading into the winter, a dormant rest period much-needed by plants to renew their energy.

No season is more vital to feeling positive than spring. It carries with it a sense of a new beginning; a feeling of hope of what is to follow in the months ahead. I can bring positive energy into my life each time I paint a spring subject, and you can too.

Standing Tall

38 x 56cm (15 x 22in)

The title of this painting represents how we should all be proud of who we are.

Declutter the mind

Spring cleaning is an activity that historically used to be carried out annually, to get rid of clutter in the home and to clean for the year ahead. While the origin of spring cleaning is somewhat confused, it was always in spring due to there being more sunlight, which highlighted dust and cobwebs that couldn't be seen as easily in the darker winter months.

Spring cleaning can be related to shining a light on things that may not have been so obvious before, and spring can be a great time to declutter your life in general. Each year I take time to look at what I have done over the last twelve months, what I am currently doing and what I plan to do in a positive way to improve my life and my art. It is definitely time well spent. Sometimes I realize I need to spend more time relaxing or with friends. But I make those decisions and enjoy putting them into action.

Stand tall

If you are unhappy about anything at all in your life, rather than move ahead holding onto issues, deal with them or put them away permanently so that they don't drag you down. See the beginning of each approaching new season as a time to move forward and an opportunity to enhance your life.

Stand tall in your beliefs and have the courage to face a future that is not hindered by negative influences, but instead is positively brilliant!

Simplify as much as you can. This too helps.

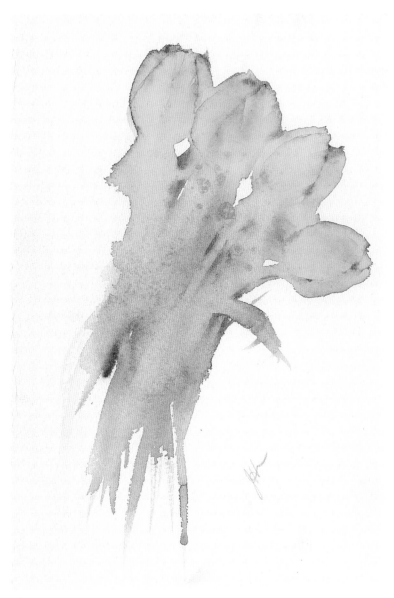

Simple Things
18 x 28cm (7 x 11in)
Simplifying a painting can be a perfect way to remind us to simplify life as well!

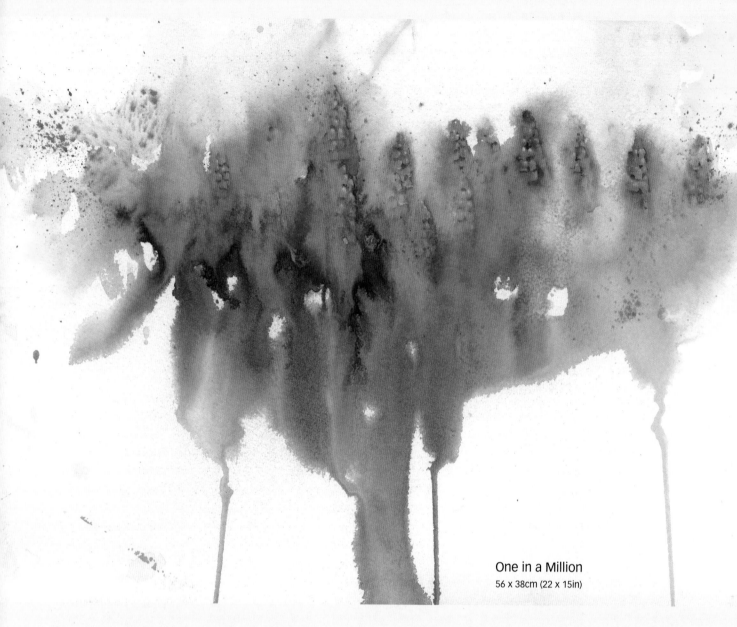

One in a Million
56 x 38cm (22 x 15in)

Learning to prioritize

When we get rid of unnecessary clutter in our lives we are left with what is important. It is the same with art. Prioritize your life and your creations. Choose how you spend your time wisely. Try new things. When creating try to be unique. You don't have to be one of a crowd painting exactly the same things in the same way as everyone else. You are one in a million. Your approach and style of painting may be different from others and that is perfect, because artists need to be different.

Believe in yourself. Have the courage to try new ideas, new subjects, new products and new techniques. With technology and social media today we have access to techniques and artwork that should keep us inspired by great new ideas for years to come. Don't get stuck in a rut, as that can make you become bored with creating and eventually bored with life.

Use spring each year as the time to find a whole new you. Hold on to what you like about yourself and your art, and move away from what you don't. No-one is perfect, and we can all be better, if we allow ourselves to be.

Positive thinking can change who we are, how we feel and how we live. It can have a wonderful positive effect on those around us too, making our whole lives enriched and satisfying.

Starting small

What can you get rid of or change? Think about it while you paint my next exercise, *Seeing the Light*. Before that, try practising with the mini-exercise on this page.

When approaching any new challenge, it is wise to take small steps first to find your way and build your confidence. We are now moving from smaller simple exercises to paint ourselves positive towards slightly more finished work; pieces that you might want to be framed. If you are new to painting, please don't let that thought panic you.

We often overthink things in life and we do in painting also. Some of my best paintings have been created when I wasn't really trying. Let colour guide you in this small exercise where you will be getting used to making brushmarks. That's all.

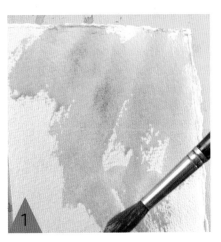

Spontaneity adds joy to life

Take a piece of paper and cover it with a colour of your choice (1). Next practise adding a few blue shapes to represent blue flowers on top of the drying base colour (2). Paint randomly, not tidily. Have fun. Relax and let go and do this quite quickly (3).

The small 'warm-up' piece

Painting a tiny piece – this measures just 10 x 17cm (4 x 6¾in) – can work like a warm-up for the full exercise overleaf.

> ### Painting doesn't have to be serious, it can be joyful, bringing with it a fabulous sense of positive energy.
>
> *Stay focussed on how you feel when creating, rather than worry about what lies ahead. We are in the now, the present, not tomorrow. Wasting time worrying about what might happen is another negative way of thinking that can seriously hold us back in life. No negative thoughts belong to you whilst you are painting. Let them all go!*

»» Positively growing

Getting bigger and gaining confidence

Working on small exercises, as on the previous page, helps us in so many ways. We learn what works from them so that when we later tackle a larger painting we possess the confidence to create on a larger scale with ease.

When I wake each morning I try to imagine what is to be the most important part of my day and I aim to make it just that, important. Conserving my energy to enjoy it and make it the best it can be. Knowing where to place our focus and energy in life and in art is vital. I believe we can learn so much from painting that can carry a positive influence on our lives. Think about what is important to you in your painting and in your life whilst you are creating. Learn from each brushstroke.

Taking on any new challenge, especially on a large scale, can seem daunting. But in this next demonstration the move is towards creating a large scene, simplifying the subject, saying as much as possible with very little detail and creating a sense of atmosphere. The idea of this painting is to imagine a really bright future or destination where you would like to head for. The positive light in the distance.

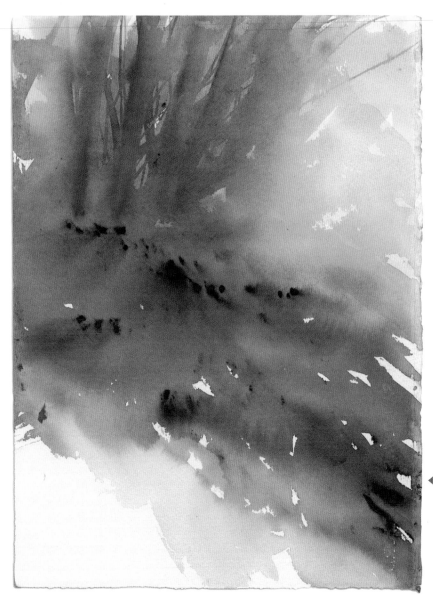

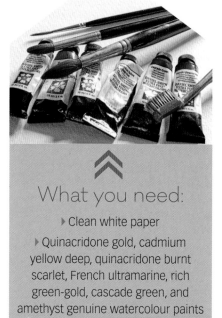

⌃⌃ What you need:

▸ Clean white paper

▸ Quinacridone gold, cadmium yellow deep, quinacridone burnt scarlet, French ultramarine, rich green-gold, cascade green, and amethyst genuine watercolour paints

▸ Large, medium and small brushes

▸ Clean water

▸ Old toothbrush

Seeing The Light
38 x 56cm (15 x 22in)

The atmosphere of this bluebell wood is captured here through the use of little detail and a glowing light in the distance. White paper adds to the gorgeous, surreal, light effect.

1 Begin by placing a lovely directional yellow wash across your paper using flowing brushstrokes. You could of course paint a blue sky for your background wash; but as I am creating a bluebell wood, I thought the yellow colour in the backdrop would act like sunlight and give me a beautiful contrast.

2 For the foreground, connect the yellow wash with a green shade continuing the diagonal brushwork. This leads the eye towards the lower corner on the right-hand side.

3 Begin to add some trees in the distant background. I placed them lightly in the upper section of my painting as I want my bluebell area to be the most important section in the foreground.

4 I now add some strong blue diagonal flowing lines to represent the beautiful bluebells. These are actually the most important part of my painting so my focus as the artist is on these.

5 I want my initial dark blue lines of colour for the bluebells to act as a soft background for the detail I will be adding later. While my last blue line is still wet, I use my medium brush to soften the dark placements of colour so that they look interesting rather than defined. When we see wild bluebells growing in the distance, we can't make out individual flowers; so in a painting it's important to suggest clusters of colour as well as individual flowers.

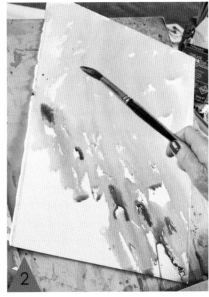

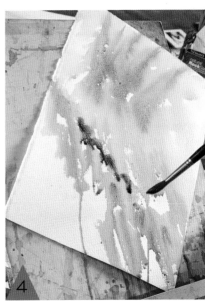

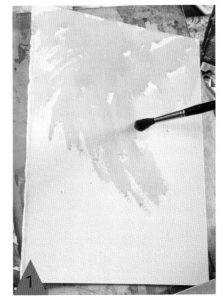

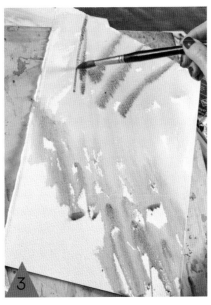

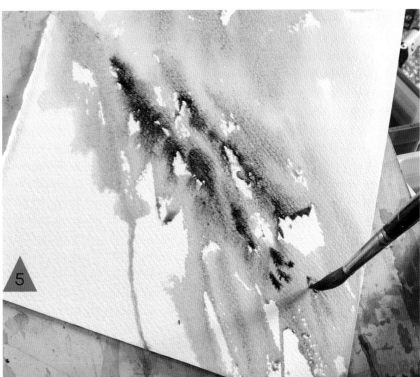

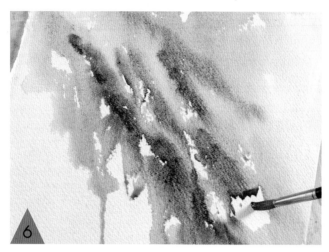

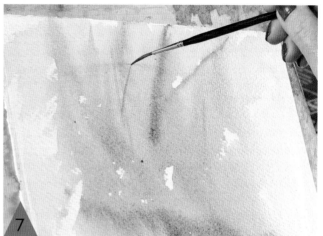

6 When this softened area of blue is completely dry, I can paint some strong individual flowers on top of my bluebell background. I make some shapes larger as they come nearer to the foreground section. Keeping the colour light in the background gives an illusion of distance.

7 Next I can look at my background. I don't want it to be so overpowering so that it takes away the attention from my bluebells in the foreground, but it is part of the story and I want to just make out that there are trees there. To achieve this I strengthen one or two trees with quinacridone burnt scarlet, keeping the light on some of the trunks. By painting dark shapes between the trees, I keep a sense of light on the trunks. This technique is known as 'negative painting'.

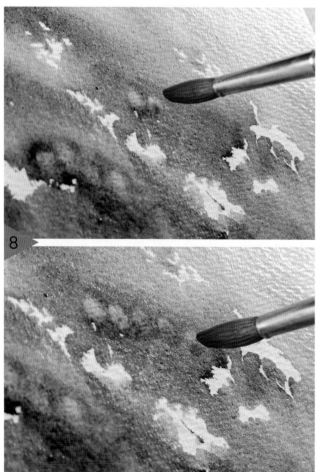

8 Now it is time to add interesting detail, to add to the story of the composition through careful placement of brush marks or additions of colour. Here I'm using a clean damp brush to 'lift' colour to form a few individual bluebells. I can only use this technique when the original colour is almost dry. If you try to lift colour while the pigment is still very wet the result will be huge watermarks which wouldn't work for the effect I wish to achieve: instead, I patiently wait for my blue colour to be almost dry and then I begin to create these beautiful patterns.

Patience is a gift in life that we can learn from painting. It can also aid us in many other things besides our creative efforts. It is definitely worth thinking about.

•••••••••▶

Opposite:
My finished piece
38 x 56cm (15 x 22in)

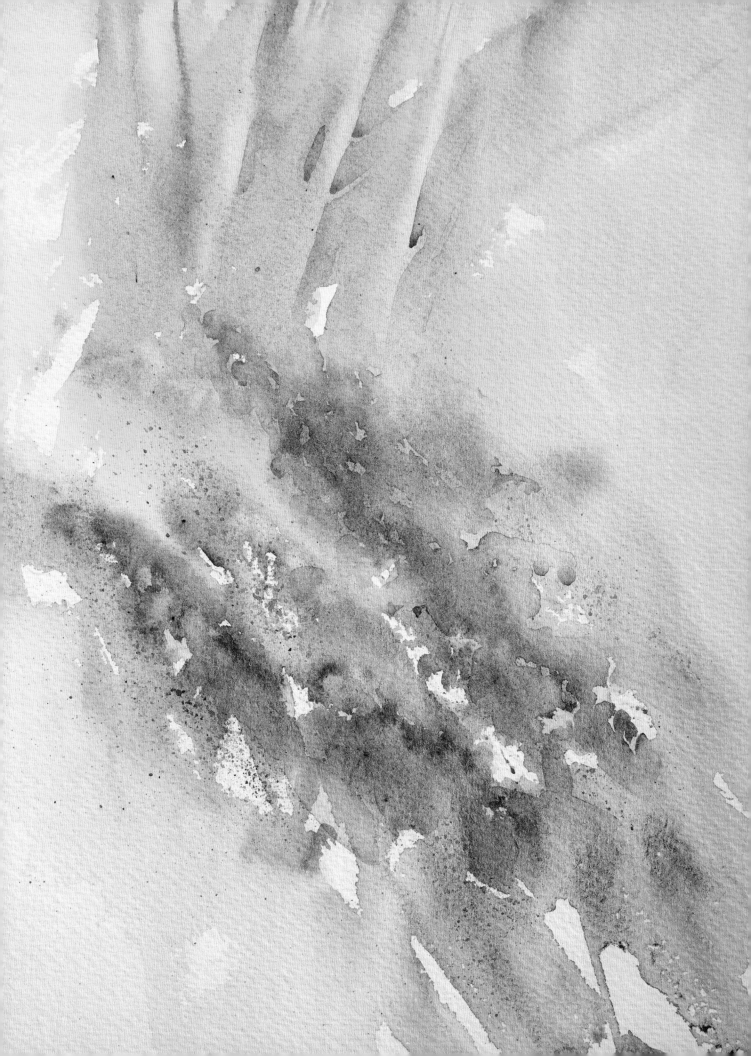

The confidence journey

Now repeat the *Seeing the Light* exercise. Rely on the confidence you have gained from practising on the small painting (see page 59) and from the first large one (see page 63) when you create your second version. Take the things you really loved about each into your next large painting. Recreate sections that worked and leave out sections that did not. You can add more detail or less; use brighter glowing colours or softer ones. The point is you can choose what you want to change in your painting. You will learn from each new creation what suits you and what you really enjoy doing.

Interestingly, what we learn from art we can use to improve our lives. Imagine learning, just as we do in these exercises, to put any negative experiences in life behind us by not repeating them. Imagine loving something so much that you know you will enjoy it if you do it again, in life and in art.

Just as you can choose to paint beautiful paintings that get better each time you paint them, you can also improve your life in exactly the same way. You can make decisions to have a more positive outcome in every single thing you do on a daily basis. Admittedly, there are some things that are completely out of our control, but how we deal with them is important: positively.

When painting your next piece of the same composition, you should know which colour you want to apply for the background, and how strong your colour application will be. If you enjoyed painting the bluebells, add more. Perhaps add more or fewer trees. Whatever you do create, this is your time to paint, reflect and enjoy. Leave your painting time feeling refreshed, energized and a new person, looking forward to whatever tomorrow may bring.

Into the light.

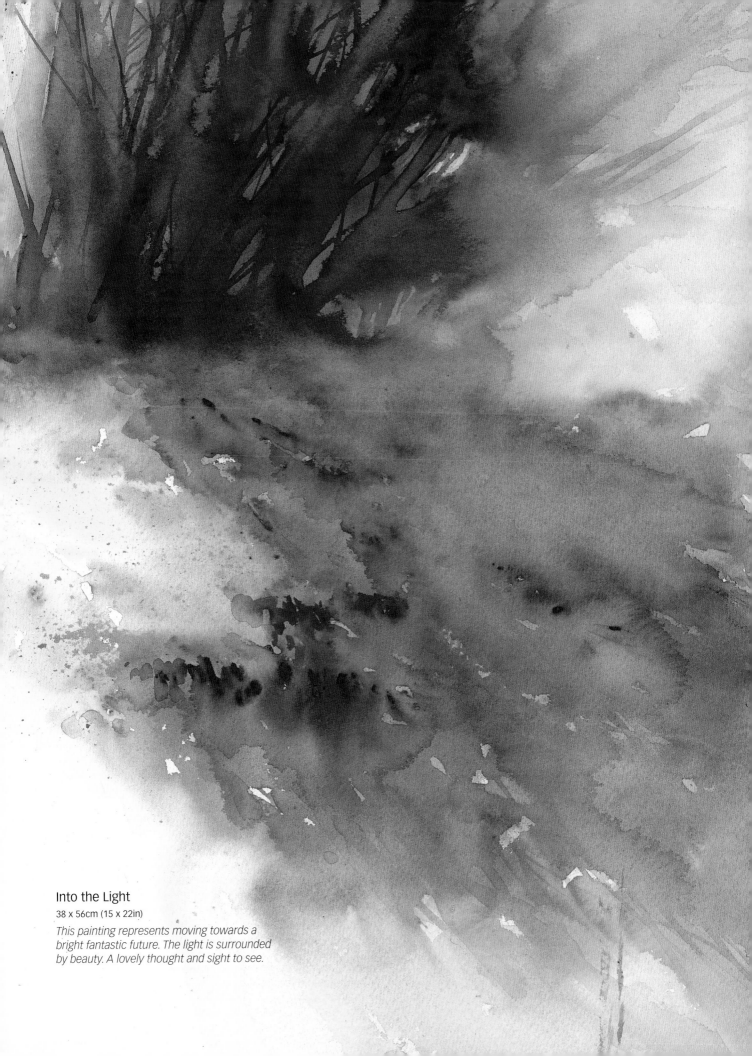

Into the Light

38 x 56cm (15 x 22in)

*This painting represents moving towards a
bright fantastic future. The light is surrounded
by beauty. A lovely thought and sight to see.*

Getting to the point

Looking after yourself: positive benefits

'Our bodies are our gardens, to the which our wills are gardeners.' William Shakespeare

It may seem common sense to look after ourselves but it isn't something we all do to the best of our ability. For example, there isn't a lack of information on how to eat healthily and yet many of us ignore the available advice.

Thinking positively can affect many aspects of our lives, just as creating wisely can greatly benefit our wellbeing. Perhaps the key to good health and positive thinking is having balance in our lives.

It is fascinating that when it comes to looking after anything other than ourselves, we do it well. For family members, pets, gardens or even our cars, we seek the best way to care for them. But when it comes to doing what's best for us? Well, some of us falter. However, to lead a full and happy life being healthy is definitely a plus. So in this section of my book, I show how to paint subjects that are good for us, in the form of beautiful fresh fruit and vegetables.

In the painting on the opposite page, a gorgeous composition of fresh vegetables is created out of glowing colour. It is quite easy to achieve this in simple steps, by painting one vegetable at a time before placing them all in one large painting. Of course, you need ideas on what to paint. Try taking photographs at your local market. Search for fresh fruit and vegetable suppliers where you know there are going to be stunning displays of colour. Look for variety, shape and texture in each new edible subject. Mushrooms are beautiful to paint, as are onions. Any green vegetable with veins, such as lettuce or cabbage, make great interesting paintings too. But don't just paint them: look up their origins and what value they have if you add them to your diet. Perhaps go a step further and think of different ways to cook your subjects so that you can enjoy eating them. Look for foods that are positive in that they are great both to paint and to eat.

Seeing in the dark

As a child I was told that eating carrots would help me see in the dark. As I enjoyed eating this particular vegetable, it was never a problem for me to clear my plate; but as an adult I wondered about the origin of this tale, and discovered an interesting story behind the old-fashioned belief. The idea that carrots can help you see in the dark originated via a myth started by the Air Ministry during the Second World War. The story was created to prevent the Germans finding out that Britain was using radar to intercept bombers on night raids. Press releases were issued stating that British pilots were eating lots of carrots to give them exceptional night vision. This fooled the British public as well as German High Command, and the story of carrots giving night vision lived on: my grandparents could never be convinced otherwise!

Eating carrots can improve your night vision but only to the point of a healthy person. Not change your sight so that you can really see everything clearly in the dark. Either way, as they contain vitamin A, they are still good for you!

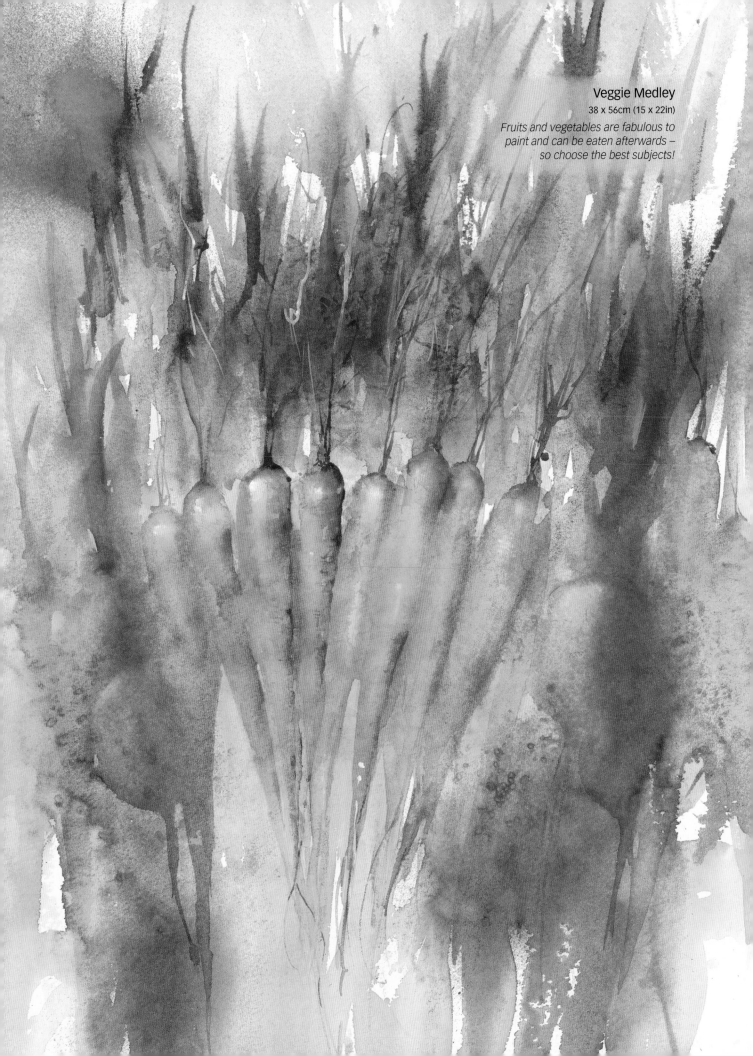

Veggie Medley
38 x 56cm (15 x 22in)

*Fruits and vegetables are fabulous to
paint and can be eaten afterwards –
so choose the best subjects!*

Not just fruit or vegetables!

Positive compositions

Once you have found your chosen edible subjects, try taking photographs of them in different lighting. Look for shadows. Creating a stunning composition by building the scene beforehand can be as enjoyable as painting in itself. Perhaps lay them on top of different surfaces: paper, plates or even greenery from the garden.

If you prefer to paint from life there is no need to take photographs, although keeping resource images aids your painting of the still life when the edible subjects are past their best.

Now you have exercises to help you choose your subjects, help you place them in beautiful compositions for still-life work, and the possibility of a healthy meal to eat after you have spent time painting.

But for now, let's paint!

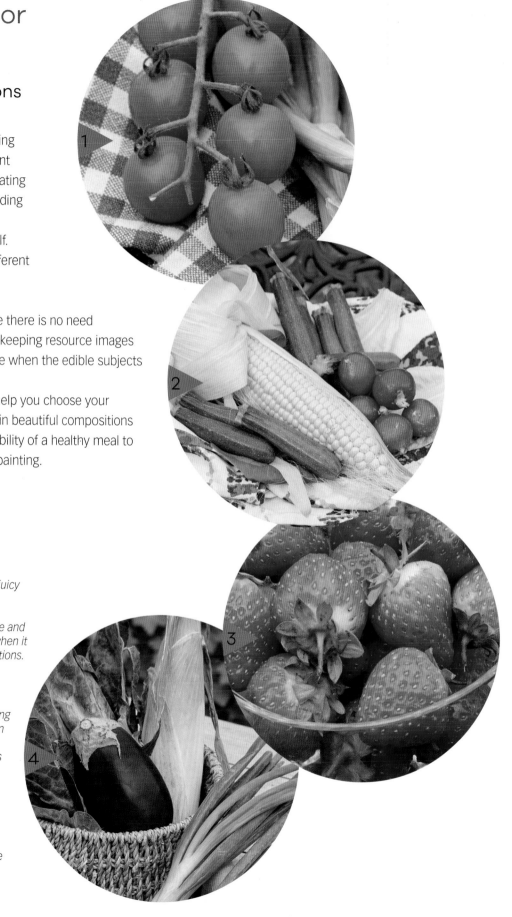

1. Fresh cherry tomatoes: Healthy, juicy and ripe.

2. Look for a variety of colour, shape and texture in your potential subjects when it comes to creating still-life compositions.

3. Don't just place your subjects in any fashion and hope it works. Taking care in all aspects of life and art can pay off. Take your time and find a composition that appeals to you, as I have overleaf.

4. Simplify your compositions by limiting the number of different subjects you choose to paint. Remember, sometimes less is more beautiful in an artwork.

Positive homework

Find out more about each fruit or vegetable you paint.
Expand your knowledge of it and, as you do so, increase
your thirst for more information. Eating your new finds
will help you have both a healthy body and healthy mind.
Positive effects all around.

» Cherry tomato

Remember that painting with red shades is energizing. It is a feel-good colour, with positive connotations. In the Chinese tradition of *feng shui*, round shapes are said to be better than hard straight lines, bringing good fortune with them; which makes painting tomatoes or other round red subjects ideal!

Observe the colour of your subjects. Not all tomatoes are just red in colour. There are green, orange and even yellow tones. Carry out a few colour sample exercises on a scrap of paper to get a great idea of your favourites before you start painting. That way you can discover the shades you would like to use. Absorb the energy from every red shade that you opt for as you create. Let it warm you, energize you and simply help you feel good.

⌃ What you need:

▸ Clean white paper
▸ Perylene red, cascade green, cadmium yellow deep and rich green gold watercolour paints
▸ Medium and small brushes
▸ Clean water

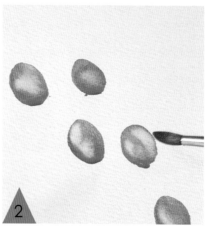

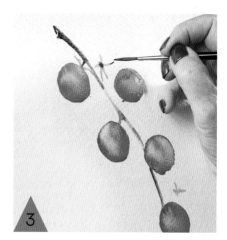

1 Begin by painting a few basic circular red shapes for your tomatoes. If you are working from life, try to make them match your real subject closely, but also make each one slightly different from the one next to it for a pleasing composition. You can leave a gap between them or place them closer together as you wish. I have created round red circular shapes, some touching each other; some individual. Don't think about how you are going to create. Just enjoy creating positively and with confidence.

2 Before the red pigment of these circular shapes becomes completely dry, use a clean damp brush to lift out some colour, using circular brushstrokes towards the edges of each tomato. This will give the impression of a beautiful sheen, as if light is hitting them individually. See if you can lift colour gently to see the white paper showing through.

3 Add greenery for the stems. I have added the green tops of a few tomatoes that were missing. (Actually, I ate them before I had finished painting the scene; but I know they were good for me, and the missing tomatoes add a sense of mystery to my results. The title could have been *The Missing Tomatoes*!) Think about what is important in this painting. The tomatoes are so make your brushwork for the green stems minimal.

In the same way that in life you must learn to give more time to what is really important to you, learn from your painting exercises. Learn where the focus needs to be each day. And grow positively.

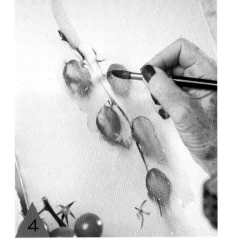

4 While the pigment is still damp, gently soften some of the edges of a few tomatoes to give a blurred effect which contrasts with other more defined edges, making them look more beautiful.

ARTIST'S TIP

If you wish, you can use a clean dry tissue to remove further colour while the paint is wet: a useful trick to add an extra sheen.

The finished piece

To finish, add detail as you feel is needed to complete your work but avoid adding too much. Keep your work interpretative, fresh and full of positive energy.

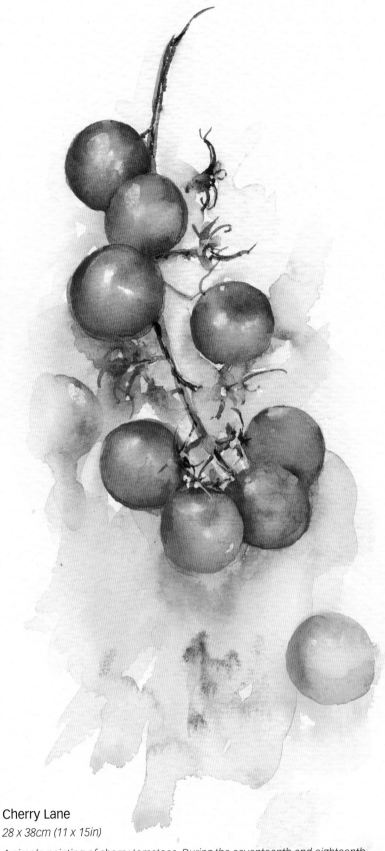

Cherry Lane
28 x 38cm (11 x 15in)

A simple painting of cherry tomatoes. During the seventeenth and eighteenth centuries, tomato fruits were often used in Italy as table decoration. During that time, Italian botanists created countless types of tomato via selective breeding which made them a valuable subject in still-life paintings. In the nineteenth century, the tomato was called pomme d'amour, *or 'apple of love' in France.*

What next?

Now repeat this exercise using other fruits or vegetables. Strawberries make fantastic subjects. Below you can see my simple painting, entitled Strawberry Fields, as an example.

Study the stages in my painting to the right, and see whether you can write the descriptive text to go with each image (you can use the cherry tomato instructions on the previous pages to get you started). Think carefully of what each stage is trying to get across from the starting point to the completed painting in the creative process. Then follow your instructions and see whether your description works.

This challenge helps you think about how and why we paint as we do; instilling what we know works. This is positive action; and this thinking brings with it an effective approach to any painting, as the thought beforehand eliminates any problems that may have occurred without such pre-planning.

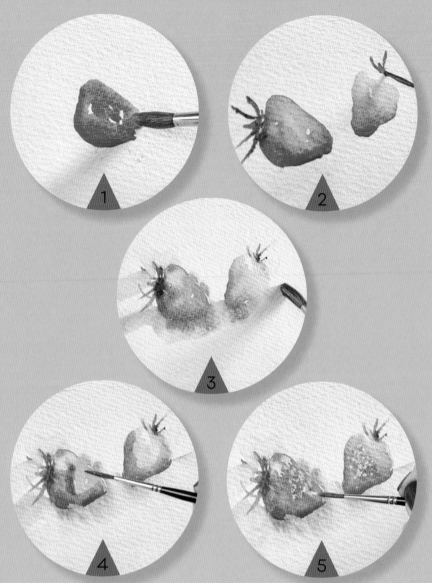

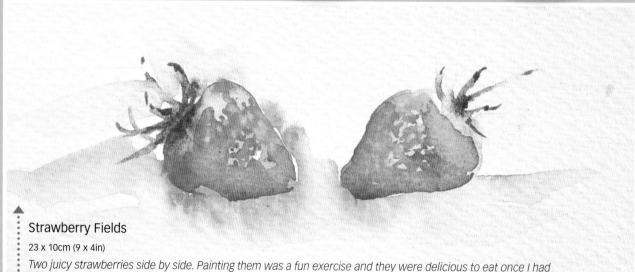

Strawberry Fields

23 x 10cm (9 x 4in)

Two juicy strawberries side by side. Painting them was a fun exercise and they were delicious to eat once I had finished. Interestingly, I was once advised to always take the time to smell strawberries as they grow, because they are said to be related to the rose family. They do indeed carry a sweet fragrance but I had no idea they were connected with my favourite flower.

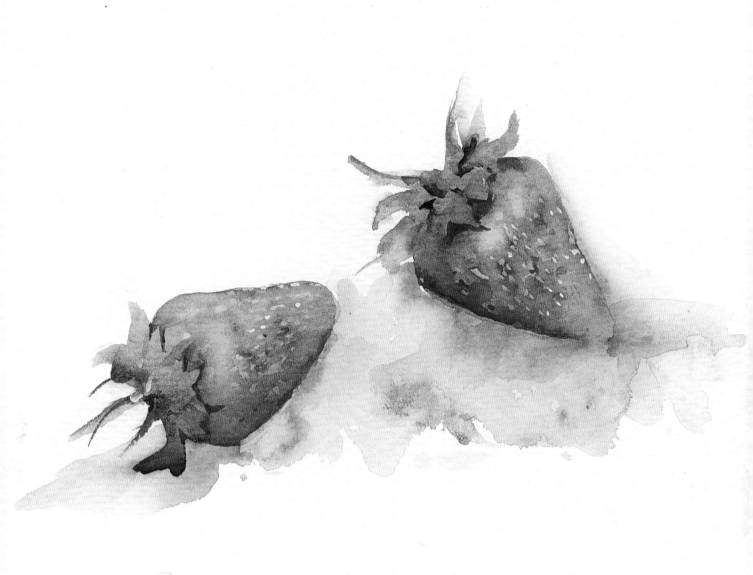

Side by Side

28 x 20cm (11 x 8in)

Taking our time to add intricate details, as in the foliage and the shadows added under the fruits here, can enrich our skills as an artist. Repeatedly painting a familiar subject until we gain confidence can help us to improve, too.

Less is more in many aspects of our life, including perhaps diet! Here the focus is simply in bringing out the beauty of what we see. Imagine smelling fresh juicy strawberries as you carry out this exercise. Imagine eating them. Imagine picking them on a summer's day. Imagine smiling as you do so, glowing positively. Imagine not just painting fruit but making yourself feel so happy at the same time, simply by moving a brush. A rather incredible feeling which we can achieve by taking the time not just to paint, but to paint positively.

Reaching goals

Being different, as an artist and a person could be the best thing that has ever happened to you!

To be happy with where you are in life is a goal many wish to achieve, but perhaps knowing where you are heading is the greatest gift of all. This chapter is about setting goals and making sure that some are achievable.

It is invigorating to have a wish list that includes goals which you may think are out of your reach, because it is soul-enriching to have a dream to work towards, no matter how big or small that dream may be.

It is worth bearing in mind that there is nothing negative about reaching for the stars; but the opposite is true if you don't even try. Look at where you are in your life and imagine where you wish to be. Never worry about where you have been. That is in your past and out of your control. Place your focus solely on where you are heading, especially when creating. What you painted yesterday can be improved upon tomorrow.

Each step, each learning curve, each brushstroke can lead you to a wonderful destination, of where you might like to be not only as an artist but also on a personal level. 'Try not to always be influenced by others' is wonderful advice. Shine in your own right.

•••••••••••▶

Opposite:
All That Glitters
28 x 38cm (11 x 15in)

Goldfish painting created using watercolour and gold powder. All that glitters may not be gold but when we allow ourselves to shine on a personal level, we can achieve anything we wish to by thinking positively.

'A goal is not always meant to be reached, it often serves simply as something to aim at.' Bruce Lee

» Goldfish

For this exercise, you can paint your goldfish on paper that already has colour on it or on clean white paper. Begin by imagining where your fish is headed. Where is it swimming from and in which direction is it heading? While you are working this out, you can place the focus on where you are heading in life, too!

After creating the outline shape of a goldfish in an orange shade, by moving your brush, you fill in the outline with colour. Use water to allow the paper to shine through your subject to give it a sense of transparency.

What you need:

▸ Clean white paper
▸ Cascade green, cadmium yellow deep, cobalt turquoise, perylene red, Aussie red gold, and amethyst genuine watercolour paints
▸ Large, medium and small brushes
▸ Plastic wrap
▸ Clean water
▸ Bronzing powder is an optional addition if you wish to make your painting shine – I used Schmincke Aqua Bronze rich gold

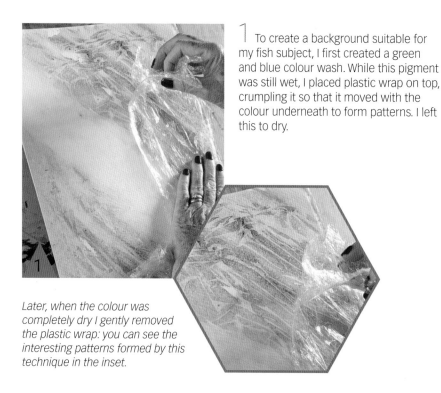

1 To create a background suitable for my fish subject, I first created a green and blue colour wash. While this pigment was still wet, I placed plastic wrap on top, crumpling it so that it moved with the colour underneath to form patterns. I left this to dry.

Later, when the colour was completely dry I gently removed the plastic wrap: you can see the interesting patterns formed by this technique in the inset.

2 For the fish, begin by painting the head and then move towards the tail. As the tail could be moving, keep this section quite simple and blurred with softened edges. Use your fingers to sweep the still-damp colour on the tail into the section of paper the fish is swimming away from.

Interestingly it doesn't seem quite as easy working from the back to the front with this subject. As in life; moving forwards, not backwards, gets us where we wish to be more speedily.

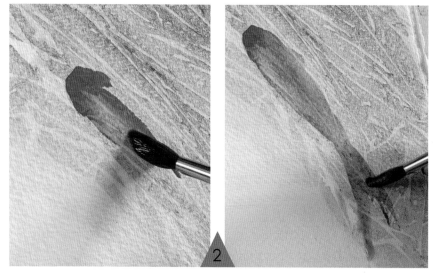

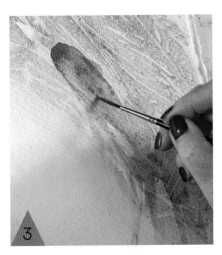

3 As you paint your fish, try to let the colour of the background show through in some sections of its body area. This will give you a beautiful illusion of light hitting the fish and also add to the sheen of the subject. When you have painted one fish, try adding another, perhaps swimming in the opposite direction.

At this point in your painting, you could think about where you're heading in life, and where your positive goals lie. Perhaps consider what dreams you would like to make come true. As you add each new fish, think about new goals you could make and how you could reach them. You could even paint small fish to represent small goals and larger fish to represent bigger ambitions. Believe you can achieve whatever you wish. There is power in positive thinking and this is a power you possess.

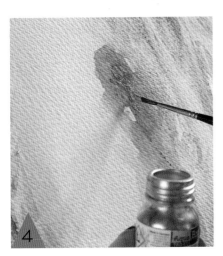

4 Try to avoid painting every single part of your fish, because in life they would be moving and seeing complete moving subjects is often quite difficult. Leave varying sections of each fish missing so the viewer of your finished works can use their imagination. For extra interest I added gold bronzing powder to my fish while the colour was still wet, literally turning them into gold goldfish.

5 Next you can begin to add green for either a watery backdrop or defined pond plants, surrounding your fish at this stage. This will add interest and increase the sense of movement and direction in your painting.

In China, both fish and gold are seen to be lucky, so these two elements combined should make your finished painting extremely lucky for you.

6 To complete your painting, you can add detail to strengthen the colour of the fish and you can also add extra greenery for the pond foliage. If you wish to, of course: when painting for pleasure and to gain a sense of positivity from our creative experience it is wise to remember we can put the brush down at any given point when we feel great. That is the main goal. Not a frameable finished painting, but to leave a painting session feeling positively glowing.

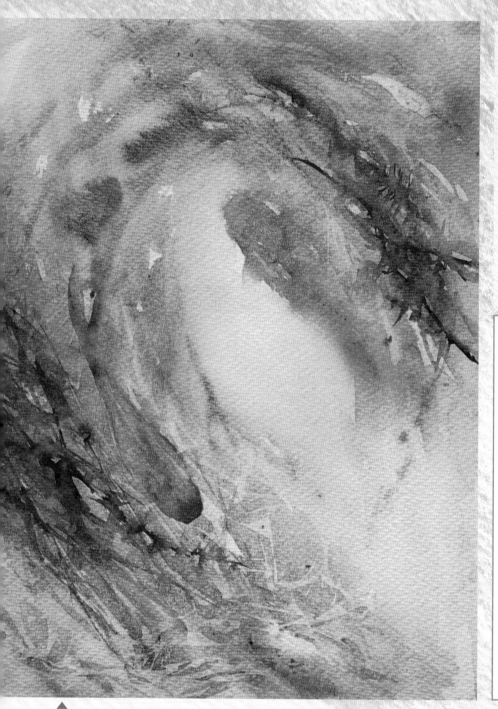

ARTIST'S TIP

You may find it easier to paint just one fish on a scrap of white paper first, in order to see how you can form the head body, fins and tail. When you later integrate the subject on top of a background wash, it is then more fascinating to lose segments of the body or tail so the fish really does look as though it's alive and moving. Studying a subject alone first helps make the larger composition more relaxing and enjoyable as you will be more in tune with what you are trying to achieve. Taking small steps at a time can be more beneficial than jumping in at the deep end, especially if you lack confidence. Just as in life. Breathe and take small steps at a time when facing anything new to you.

The finished painting
28 x 38cm (11 x 15in)

Creative positive goals

- Paint new subjects regularly.

- Don't shy away from creating complex compositions.

- Believe you can achieve anything and you will.

- Try new painting products to keep yourself motivated.

- Don't listen to negative feedback on your creations. You painted to enjoy creating!

- Set a wish list of what you wish to achieve by the end of the year ahead and reach those goals.

Avoiding monotony and embracing the new adventure

It may seem easy to move in the same direction as everyone else. But what if we all did exactly the same thing, at exactly the same time, every single day? All moving in one direction. All heading towards the same place. Life could become monotonous and boring. Having something new to look forward to adds zest to life. It gives us a sense of purpose.

Having a wish list of places to go, new things to do or paintings to create is good for us. Take your time in life to savour beautiful moments, and move quickly to avoid missing any. Most importantly, dance to the beat of your own drum. You set the rhythm. Take control positively and begin right away to make a positive plan for a great year ahead.

> *'When I let go of what I am, I become what I might be.'* Lao Tzu

Following the Leader
56 x 38cm (22 x 15in)

Have a sense of where you want to go as an individual. Don't swim around aimlessly wasting time and energy getting nowhere.

Remember. Nothing is impossible.

Art tips relating to being more positive in life

Prioritize When painting, choose what is the most important section to you and make that your focal point. In my goldfish painting for example, one fish will be more important than all the others. Spending less time on less important areas of a composition enables you to dedicate more time to work on what is crucial. In life, placing focus on what is important or most enjoyable means that you spend less time worrying about anything which isn't affecting you in a positive way. Organize your time well.

Don't sweat the small stuff Less is more in a composition. Overworking or adding too much detail can kill a great painting at times, as can worrying about things that we don't need to. If something isn't necessary or important to you, don't waste time on it. If a painting isn't working, don't continue with it. Start something new. Be brave. Try a new adventure. Life is far too short, so enjoy every moment of every day doing what you love, or find a way of making yourself love what you do.

Have faith in you Avoid following the crowd just because it may seem the 'in-thing' to do. You are an original piece of art, so do your own thing. Become the one that others follow. Positive thinking and a positive attitude bring their own rewards, so if you paint differently from everyone else, celebrate! There is already a Picasso, Monet and Turner in this world. You being different as an artist and person could be the best thing that has ever happened to you!

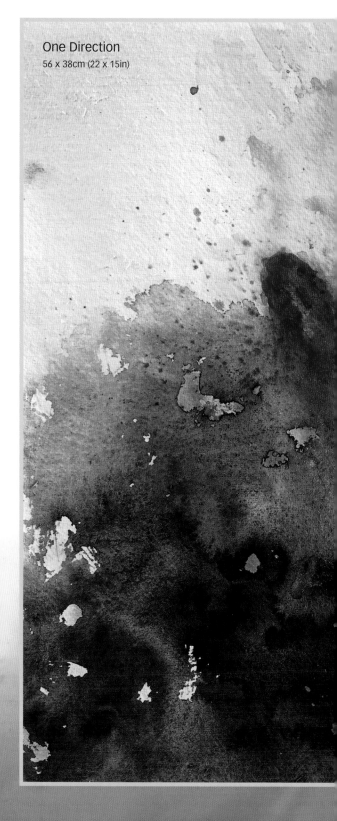

One Direction
56 x 38cm (22 x 15in)

Life plans

Sometimes the smallest step in the right direction ends up being the biggest step of your life.

Sometimes we have so much to do or so much going on in our lives that it is difficult to know where to start. Taking tiny steps and achieving one thing at a time can lead us to a better place mentally and emotionally. Gaining a sense of achievement, of having done one thing well, is far better than not having attempted anything at all. Rather than be overwhelmed, try finding a positive direction towards reaching your goals, whatever they may be.

Often when I write books, I begin with simple demonstrations which lead to more complex paintings towards the end of my publications. Not in this book. I am deliberately placing a very simple task to carry out here that anyone can do. Because art, just like our lives, can be overly complicated, having something creatively achievable and rewarding to do is a fabulous way to energize and feel great. And you can plan how you want to feel continually by doing so. A simple reminder is sometimes all we need to keep us in the right frame of mind.

The message in this chapter is simple. We may have no control over many things in our lives, but our attitude towards them is something we can alter. Being positive is a great plan to aim for as it can affect our daily lives in so many ways, no matter what we are facing.

'You can, you should, and if you're brave enough to start, you will.' Stephen King

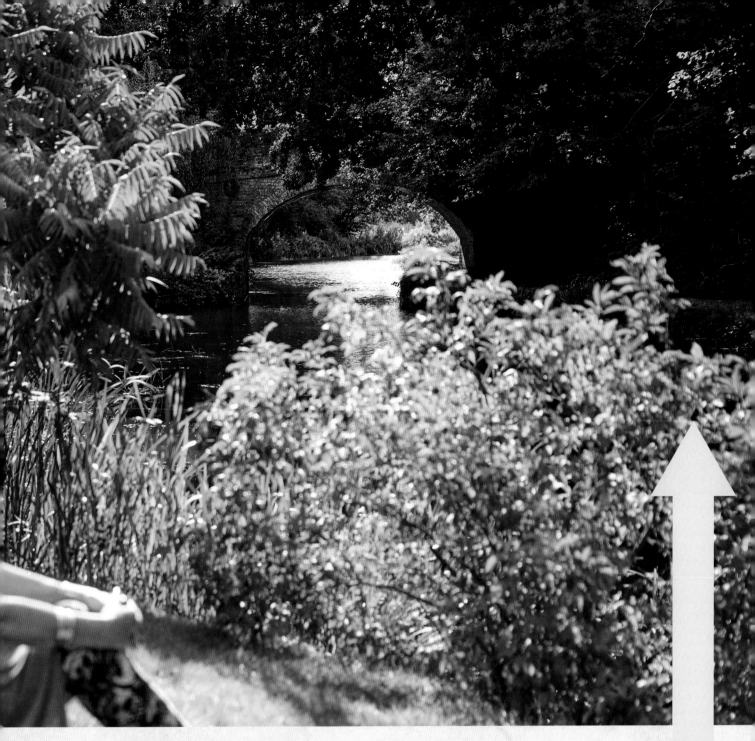

Positive thoughts

You can make paintings that include positive phrases, to hang in your home or to give as gifts to friends who you think may need them. I had such fun creating these for this part of my book. I left the painted positive thought 'I Can' on my easel and when I saw it the next day, I instantly smiled. I was faced with a daunting task but just seeing these words made me feel positively connected to what I was about to do. You can also create greeting cards quite easily with these ideas. Try buying blank greeting cards to paint and each time find a new positive word or saying to go on them.

You can use your own personal words that you know will be appropriate to what you need to see or hear. Words that can help you stay positive. There are also many wonderful famous positive quotes that can be used to inspire us. Let's get started.

⟫ Positive painting

Think of a few words or phrases that are positive and begin creating. The plan is to cover a whole piece of paper either with colour on top of a first wash (as in the example below), or to use wax to create words that carry a positive message (as shown on the opposite page).

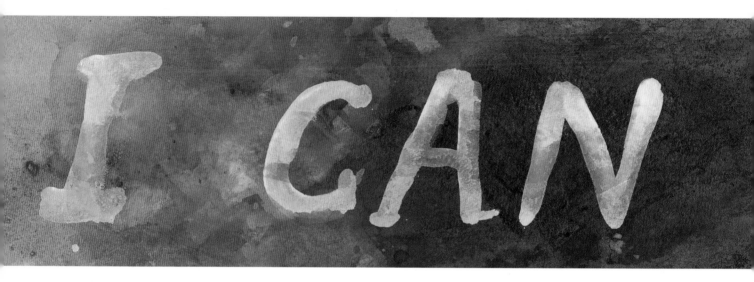

Positive painting option 1

Use this creative exercise as a plan to get your mind into a positive place. Look at the white paper before you cover it with colour and perhaps think of shades that suit what you are going to write. Red is a strong positive colour and goes well with energizing words. Yellow is cheerful. Learn about colours and their meanings so they too can add to your creative time (see pages 96–111 for some ideas). With my scrap of paper above I used many colours just for fun, and added 'I Can' with white gouache once the paint was dry.

Create a variety of paintings like the above with different words. The challenge is to see how many colour combinations and positive words you can come up with.

Painting can be a wonderful way of relaxing, like partying with colour. It can be de-stressing, yes, but it can also be totally energizing. When you have finished your painting sessions the word 'happy' should come to mind!

⌃ What you need:

Here I'm using:
▸ A mug for water
▸ A paper plate as a palette
▸ A single brush
▸ A few colours and white gouache

... but with a positive attitude, you can use anything!

84

Positive painting option 2

I prefer this method as it is more fun. You can prepare a pile of pieces of paper with secret messages to yourself, and paint on top of one a day to reveal the words.

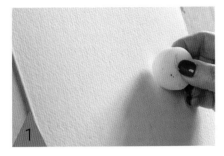

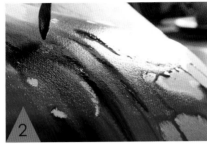

1 Take a scrap of paper and using the white candle, write words in wax over it: words that mean something to you personally. When writing with a candle your writing will be invisible so you will need to write the lettering in one go for each letter and remember where the next letter will begin alongside it.

2 Now apply colours of your own choice over the wax letters which will show through the pigment. The wax acts as a resist so colour flows around it.

The finished piece

Sometimes images say more than words ever can! Try experimenting with watercolour shades or even inks. You can create some fabulous effects so easily and these sayings can look gorgeous framed, hung in your home as a constant reminder of what you need to hear to consistently feel positive about life and painting.

This is also a great gift idea to give to a friend who also likes painting.

Framing your work

'Smile' is my favourite positive word. Try lifting the corners of your mouth and see if you can without feeling more cheerful. You can frame paintings of positive sayings, or perhaps have them printed on cushions, t-shirts or pillows to give away as gifts or to act as daily reminders to think positively. A great way to regularly receive positive affirmations that are personal to your own life journey.

Plan ahead

Plan time to paint, time for you, time to feel great, time to get new colours or products to experiment with and time to enjoy them positively. Make painting part of your daily routine to simply feel fantastic.

Whatever you are doing, be brave!

Roar
38 x 7.5cm (15 x 3in)

I chose 'Roar' because it is a terrific reminder that whatever I choose to do I am capable of doing it. It is nice to bear in mind that we are often far braver than we realize. Find your inner strength, the lion within you that may be hiding at times.

Roar
28 x 38cm (11 x 15in)

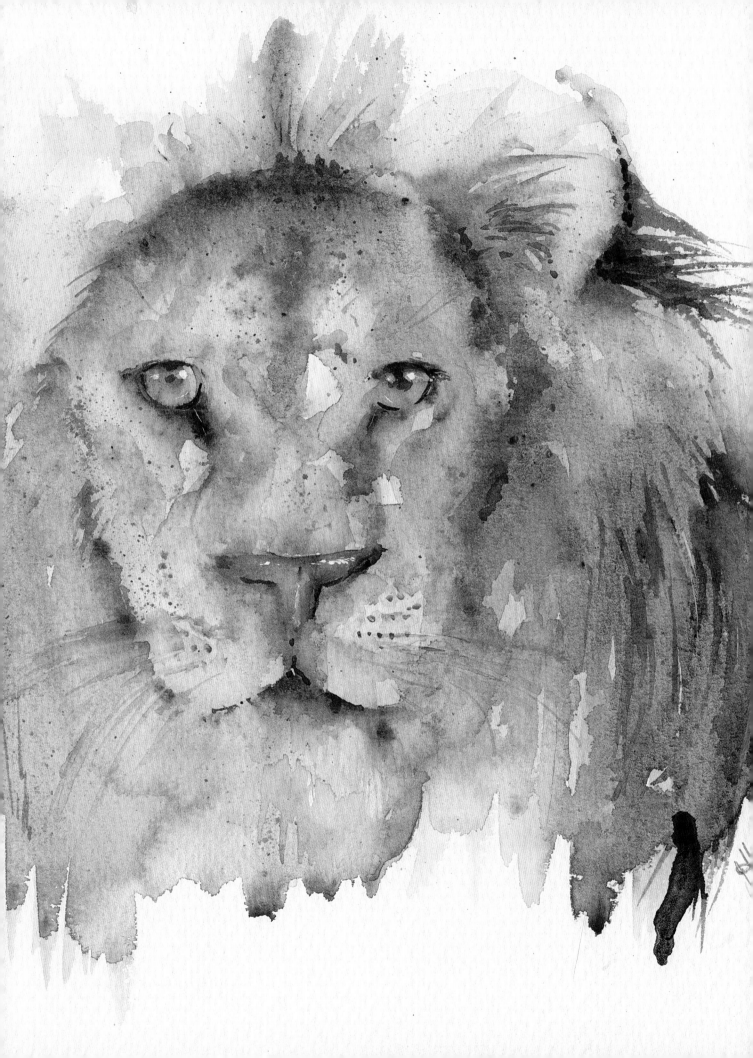

'For me, a landscape does not exist in its own right, since its
appearance changes at every moment; but the surrounding
atmosphere brings it to life - the light and the air which vary
continually. For me, it is only the surrounding atmosphere which
gives subjects their true value.'

Claude Monet

The value of a positive wish list

'I will not follow where the path may lead, but I will go where there is no path, and I will leave a trail.' Muriel Strode

Everyone has a dream, something they would love to do that may seem impossible. Since childhood, I have always kept a wish list. On it are many things, from those way out of my grasp to simple little things that make me feel brilliant when they happen.

As an artist I have always been inspired by Claude Monet (1840–1926). I always dreamt of visiting his home in Giverny, France; and one day I did. Seeing his garden and wonderful water lily pond was literally a dream come true for me. I stood silently, aware that I was standing in the very same spot that he once did.

As soon as I achieved my dream, I began thinking up another to add to my wish list.

Create your wish list

We need positive things to look forward to. Goals to reach, destinations to head for; and we need to believe that we will reach them. Any doubts need to be put to one side as they represent negative energy. I love the quote 'Believe and it will happen', but only when I use it connected to something terrific happening. I believe totally in the power of positive thinking, and you can too.

So I would like you to start thinking. What would your wish list include? Try to come up with at least ten things to put on your own personal list, and consider how you would paint them. Visualize your wishes, one at a time, then bring them to reality on paper. You see, in our everyday lives we may not always have the ability to physically see, do or hold something, but as artists we can always paint that something. That activity can bring great satisfaction; bringing your wishes nearer to you.

Favourite wish list subjects

My favourite place has to be Monet's garden and lily pond. And so I have painted it many times. But I also now have water lilies in my own garden which bring me so much pleasure. Each time I look at them I think of my favourite artist. And of the time I visited his garden. Make your own wish list of places you would like to see and paint them, bringing them to life in ways that make you feel happy. Your wish list doesn't have to include only places; years ago I would paint animals I longed to see and dogs to whom I would like to give a home. Each time I felt so happy as if I was having my own adventure. You can too. With the power of positive thinking and positive creativity.

Positive visualization

How we see things is individual to us. But I always look for the beauty in life and my art subjects. In the painting *Positive Light* (see opposite) it was the incredible light hitting the pond at a beautiful time of day that attracted me. I could have missed this view had I been racing past. A word of advice: Try not to miss the beauty in life. There is so much for us to enjoy if we only give ourselves the luxury of time to absorb the energizing power that is nature. Be kind to yourself and try to see things through the eyes of an artist. Always be on the look-out for something stunning, refreshing and gorgeous to paint. Be positive that you can!

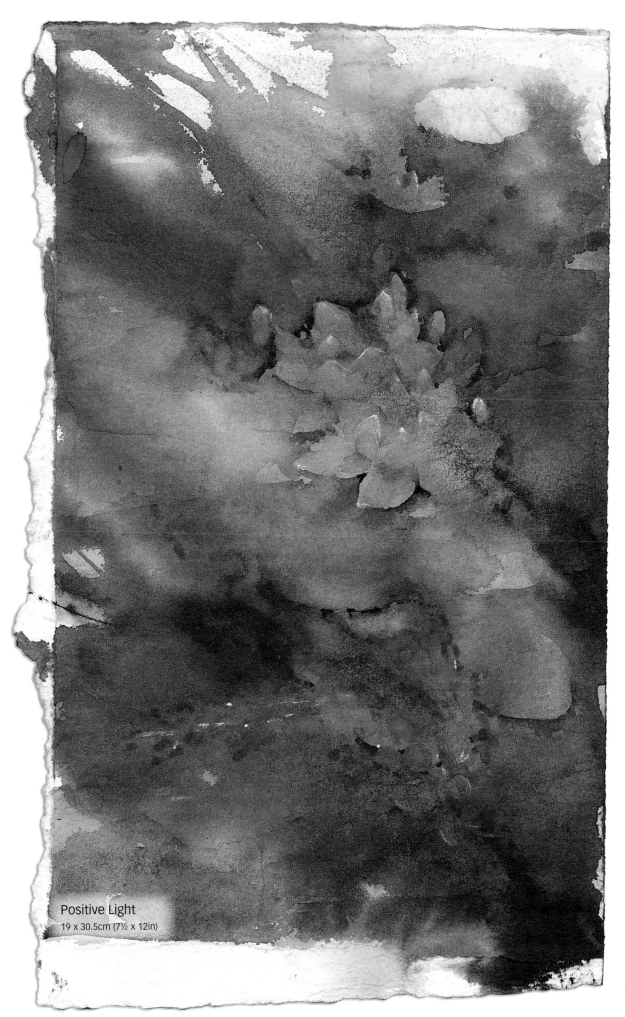

Positive Light
19 x 30.5cm (7½ x 12in)

⟫ Positive white

We begin creating by painting a wash, placing colour over a white piece of paper as shown below. I have used green and blue shades, leaving a white space in the centre where I will be adding a water lily. The white section represents positive space; something to look forward to. The light here is energizing and revitalizing energy.

When the colour is dry we can begin to add the flower. This we do by forming an outline, known in artistic terms as a negative edge (see page 62 for another example). Creating a simple outline for the lily means we have something to focus on that is positive within the painting.

Next, we can begin adding detail and surrounding leaves, looking for what is important and leaving out what isn't. Like life; we can prioritize what is most essential to gain a great result.

⟰ What you need:

‣ Clean white paper

‣ Watercolours in the following colours: cascade green, cadmium yellow deep, helio turquoise, quinacridone gold, amethyst genuine and opera pink

‣ White gouache

‣ Large, medium and small brushes

‣ Old toothbrush

‣ Clean water

◀ ················

Starting point

Colours created as a positive background for a water lily painting. You can lay food wrap over the colour while it is still wet to create the textural effects. These can be turned into lily pads with further detail later if you wish.

TIP

Whatever subject you are painting always find a focal point that you can use to add a sense of positivity to your work. A door or gate could be open in a building or landscape scene, leading the viewer to imagine that something wonderful lies behind the open door, or the pathway that the gate leads to.

In this small study of a water lily, the focal point isn't the flower itself, but the light hitting it, which brings a positive sense of life and energy into the piece.

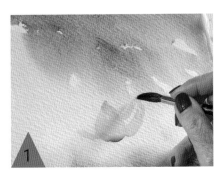

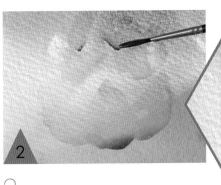

1 I begin by painting the petals of the water lily on the side that is nearest to me. Even though my subject is white, I add a touch of gold to the upper tips of each petal to give the illusion of sunlight hitting each one.

2 Next I begin to form the petals on the furthest side of the water lily. This I do by creating an outline, which we call the negative edge. I do this using the same colour of my green background. Before this negative outline is completely dry, I use a clean damp brush to blend the freshly added colour away into the background so the edges are kept nice and soft (see inset).

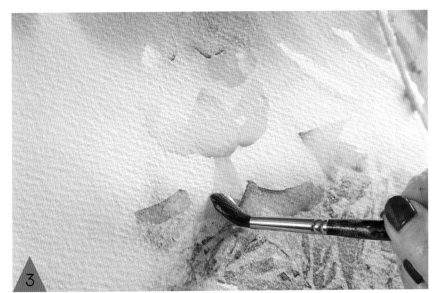

3 Now I begin to add the outer petals at the base of the outline of the water lily using cascade green.

4 I also begin to find buds in the foreground and place a dark green outline around them which I also soften with a clean damp brush to leave them fresh-looking and beautiful.

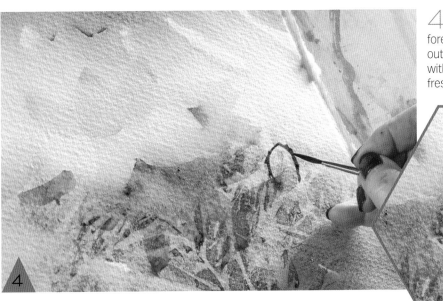

93

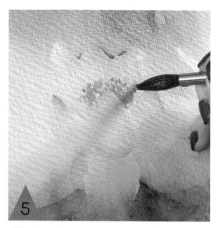

Yellow represents sunshine, so I when I'm working in this area I imagine feeling sunshine touch my shoulders, bringing with it a feeling of glowing warmth and sense of inner peace.

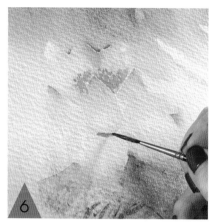

5 I can begin to add a glowing yellow for the centre of my water lily flower. This is the most beautiful section of my subject so I take my time to enjoy creating it.

6 I add a touch of pink to the base of the upper petals of my water lily flower to define the detail of separation between petals in this section.

7 I can now begin to form definition around some of the lily pads; just a few to make my painting more interesting. I can add more buds at the same time.

The finished piece
28 x 38cm (11 x 15in)

This is where a painting becomes personal and any choices or decisions you make now to complete your creation are completely up to you. Bear in mind that each painting is different and requires its own form of closure; as does any problem in life. Knowing when to stop and when to go on is so important.

We can learn so much from our creative time. My art influences who I am, how I deal with situations and life problems, and gives me a youthful energy I never knew I could possess. Art contributes greatly to my positive approach to life. It can to yours too!

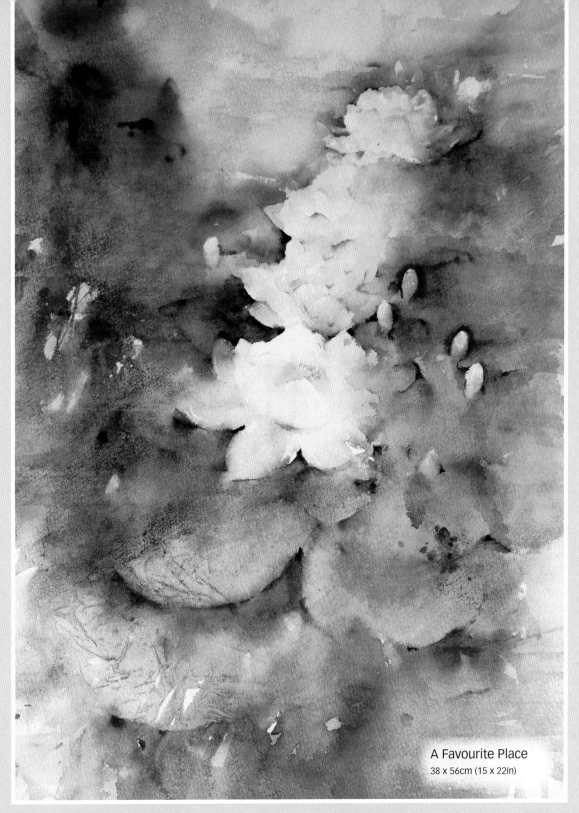

A Favourite Place
38 x 56cm (15 x 22in)

Keep your first study simple (see opposite), but then perhaps later paint a larger scene. Using the confidence you have gained from practising on the small study first, make it more fantastic.

Believe you can paint well and you will; and your sense of achievement will help you feel even more wonderful. When attempting to paint a completely new subject or technique, approach creating as an adventure each time.

Make your wish list come true by art alone. You never know: it may come true as a reality also. That is the joy of always believing in the power of positive thinking.

Time to wish, time to dream, time to look ahead positively.

Positive creative energy

Choosing colours to infuse energy into our being

Opting for powerful colours to paint with can grant you energy and a feeling of cheerfulness.

Without a doubt painting can be a really enjoyable experience. More importantly though, think about how amazing it would be to leave every creative session feeling boosted in energy and also lifted in spirits. This way of thinking about painting can be life-changing. It is possible. It works. I know because this is exactly how I create, using the most positive colours when I need them.

To achieve a sense of wellbeing from creating we need a healthy understanding of the meaning of each colour we select to paint with, along with some knowledge of the effects they can have on us. There is so much we can learn from the history of colours and how they have been used and are still used to this day. For example, it is widely known that colour can be used for relaxation and de-stressing. This is especially true for calming colours such as green, blue and violet.

In exactly the same way, powerful, energising colours can have a huge impact on how we feel. They can refresh us by recharging our batteries, leading to new-found energy. This positive feeling can increase our confidence, help us feel stronger in many ways, and improve our lives. Feeling good is healthy. It leads to a happier life. It is important. Not just to us individually but to everyone around us.

Enjoying, observing and painting with the right colours at the appropriate time for what we need from our creative sessions can make a difference. I rarely paint with energizing colours at the end of the day, for example, as these stimulate my mind so much that I find it difficult to relax after using them. However in a morning creative session, I immediately opt for powerful colours to paint with, in order to gain energy and a feeling of cheerfulness that, without fail, gets me off to a great start to my day.

In this chapter I invite you to do your own research into why certain colours can lead us to a way of feeling positive and more confident in ourselves. Here are my beliefs and findings from my own experience of painting myself positive.

Red

Known as the colour of love, red is an extremely powerful creative shade.

A strong, energizing, powerful colour. Red is physical, positive and carries great impact as a colour. It is instantly recognisable and gives a clear signal to take notice, to heed warnings, to look and listen when we see it. Effective in traffic lights worldwide, it is a demanding colour: demanding in a good way, as it can instil courage, confidence and inner strength.

Red can be stimulating and create a sense of excitement when used to paint with. It can add drama to a somewhat quiet painting. It is worth noting that the famous artist J. M. W. Turner (1775–1851) often added a touch of red to the centre of his masterpieces, which drew the viewer into the scene quite subtly and beautifully. Red added impact and he knew it did.

Use red to paint when you are feeling low in energy or when you are facing a challenge. Use it to improve your confidence levels. Use it boldly, as it isn't a colour to be timid with – especially if you want to gain the most out of its positive qualities. Try not to have any fear when painting. Increase your inner strength in both your painting abilities and in life, by working with the most powerful of all colours: Red.

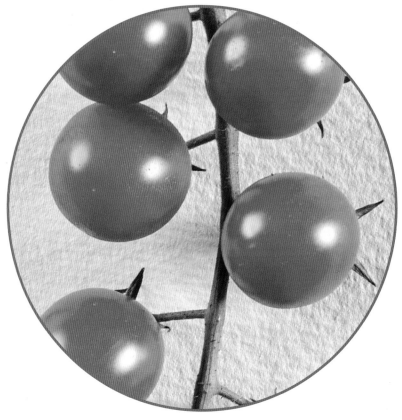

Positive energy flow

Try this very simple colour flow experiment. Choose your favourite red shade, the one that you feel is the most powerful. Draw strength from the positive energy which you associate with the colour, and try to absorb this energy as it moves and gradually dries.

What you need:

▸ Clean white paper
▸ Any red watercolours, inks or concentrated watercolours
▸ Water spray
▸ Clean water

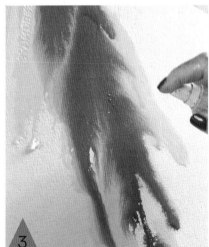

1 Place your paper at an angle, and wet a section either by using a water spray bottle or by brush.

2 Drop some red pigment onto the pre-wetted section and sit back to watch it flow.

3 You can allow the paint to flow naturally, or encourage it to move further using a water spray.

The finished piece
38 x 56cm (15 x 22in)

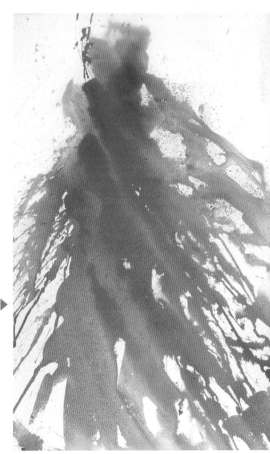

Try this exercise several times using a variety of red shades. You may find some pigments move more slowly due to their formulation: bold cadmium red, for example. Other shades will flow readily. Learn about the strengths of each one and note how they interact with water.

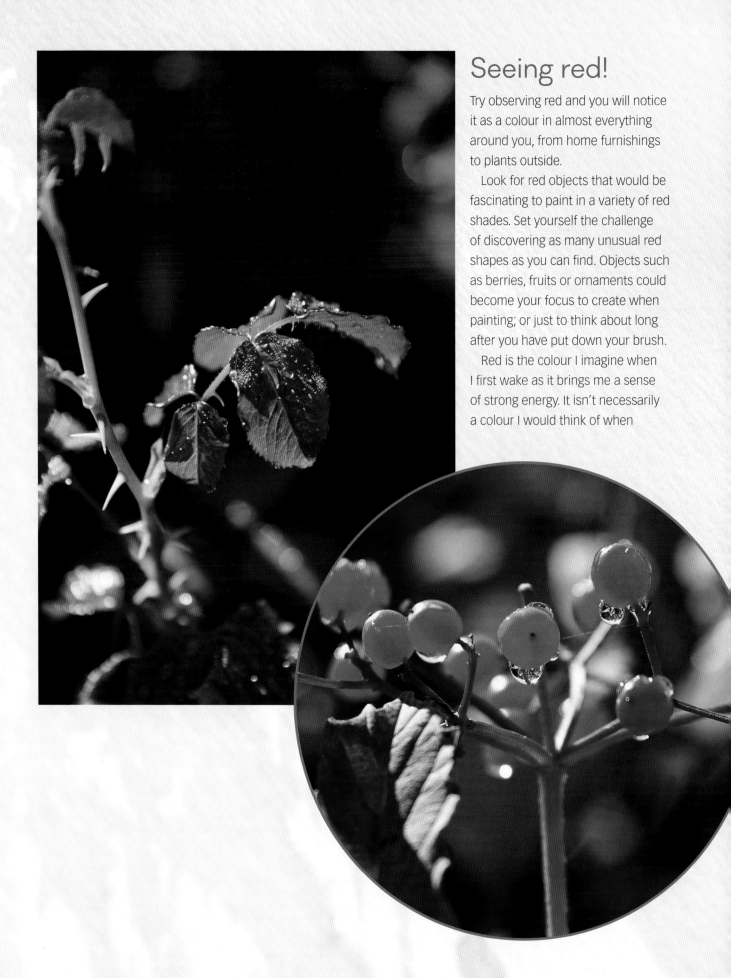

Seeing red!

Try observing red and you will notice it as a colour in almost everything around you, from home furnishings to plants outside.

Look for red objects that would be fascinating to paint in a variety of red shades. Set yourself the challenge of discovering as many unusual red shapes as you can find. Objects such as berries, fruits or ornaments could become your focus to create when painting; or just to think about long after you have put down your brush.

Red is the colour I imagine when I first wake as it brings me a sense of strong energy. It isn't necessarily a colour I would think of when

I retire in the evening, as its high-energy status could keep me alert and awake. However if I am tired in the daytime, overworked or facing a new challenge, red is the colour I immediately race towards to paint my simple daily wash exercises as seen on the previous page. These exercises bring courage into my artist's soul; they make me feel like an incredible adventurer. Believe it or not, any red shade does change my character when I am painting with it, making me feel that I can undoubtedly take on the world. You can too!

Red is not a colour to be dismissed lightly when you wish to paint yourself positive.

Red = Positive Energy

Perhaps you might like to carry out your own research as to why red has so many influential connections in colour meanings. What is so special about red as a colour? Why is it seen as such a powerful shade and how does it affect you personally when you create with it?

Yellow

Yellow = Positivity

Of all the colours, yellow has to be the one that best represents positivity. Less powerful than red, it gives an impression of bright light, warmth and sunshine. It is an optimistic colour that can aid confidence, improve our self-esteem and affect our inner emotional strength. It is a friendly colour, with the ability to add warmth to the dullest of paintings. It is wonderful to use not only on the greyest of days, but also when you are in the unhappiest of moods – it cheers you up just as the sun can when it hits your face or shoulders.

Yellow represents creativity, which makes it the perfect colour for artists of all levels to enjoy using. It is known as the strongest colour psychologically, as it can stimulate the senses, making it quite an emotional colour to create with. Try thinking about lemons and see whether you can sense the sharp taste of the fruit, or the smell from peeling them. What other colour has such a strong reaction to the senses when you think about it?

'Lemons are hard to think of without imagining their taste or fragrance.'

Feel-good warmth

If you cover a piece of paper with a colour and then use the same colour to paint on top of it, you can usually achieve a much darker result of the initial colour; a richer green or a more intense red, for example. Yellow is quite a fascinating colour in that if you try to paint on top of yellow with even more yellow, nothing actually happens! You can use water to lighten the yellow pigment, but trying to make it look actually much darker is quite difficult.

For this reason, you often need to introduce a completely different second colour, to make your yellow subjects or washes more interesting. In this exercise, I have used quinacridone gold to intensify my plain yellow wash and now the yellow colour looks more fascinating.

This really is an extremely useful tip. If you choose to paint yellow subjects such as lemons, knowing in advance that you will need an extra colour on hand to make them work in a painting can be a great help.

TIP

For this challenge, use the same materials as on page 99; just swap out the colours for cadmium yellow deep hue and quinacridone gold watercolour paints.

Adding more yellow on top of a piece of paper that's been painted with yellow won't deepen the colour, it will only give you more yellow!

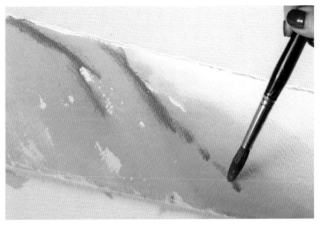

Adding quinacridone gold to cadmium yellow deep causes magic to happen.

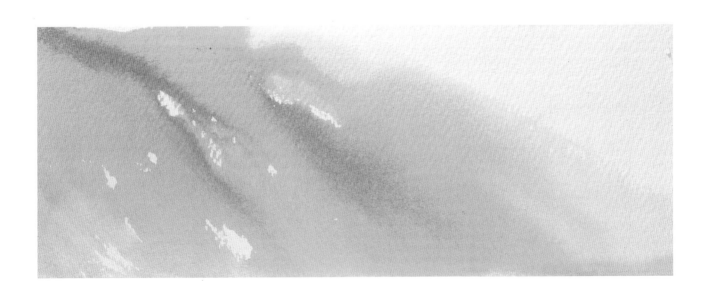

Why paint with yellow?

Yellow adds instant sunshine to any painting, and brings with it a sense of wellbeing. It gives a fabulous incentive to experiment; create with yellow shades and learn how to make them 'sing' by adding touches of other colours to help them shine.

Yellow is a feel-good colour that can add warmth to the dullest of paintings. Use yellow to lift your energy levels, stimulate your brain positively and make you feel great.

In a world of so many safe colours, yellow shouts
'Look at me, I'm happy!'

Orange

Aim to keep your youthful side by painting in vibrant, playful colours.

Orange is a playful colour, which is why it is linked to having fun. It is a cheerful colour like yellow, and far stronger when used as a mood-lifting shade. It is worth considering that in life we can take ourselves far too seriously at times. This colour reminds us that we need to have fun and avoid losing the more playful side of our youth, especially if we work hard or have a long list of things we have to do. Orange reminds us to make time to enjoy ourselves just for the sake of doing so.

Some say the colour orange is linked to representing security, comfort, food and abundance. But to me it is a vibrant, energizing colour that can lift the heart when it needs to be lifted. When combined with the colour yellow, the result is a beautiful positive balance between the emotional and psychological senses, which makes it a winning colour combination for painting yourself positive.

'Was it the case that colours dimmed as the eye grew elderly? Or was it rather that in youth your excitement about the world transferred itself onto everything you saw and made it brighter?'

Julian Barnes

Always see the positives in life

I know it isn't always easy to see the positives in certain situations, but sometimes how we approach a challenge or problem can have such a huge impact on the outcome. On the following pages, we can learn how seeing the light and staying light-hearted makes such a dramatic difference to the results of my study painting.

TIP

For this exercise, use the same materials as on page 99; just swap out the colours.

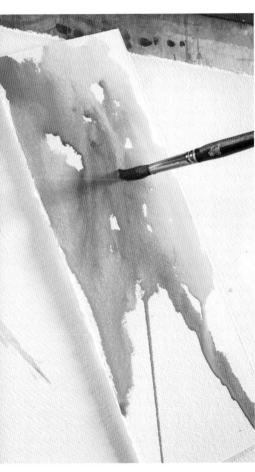

Orange is far stronger than yellow when used as a mood lifting shade.

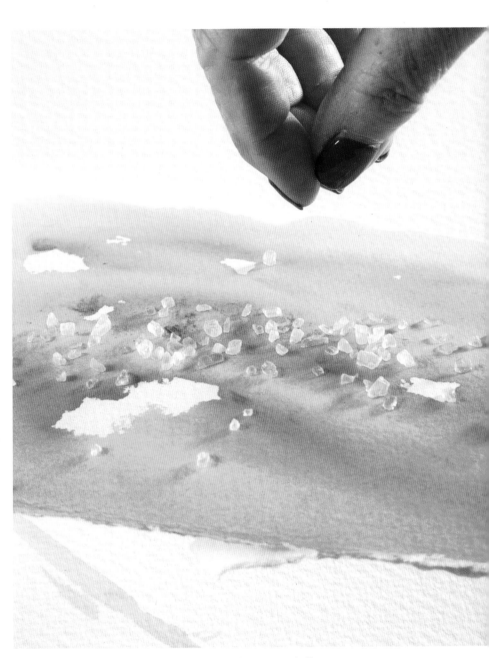

Sprinkling salt on still-wet pigment leads to fabulous textural effects.

≫ Cheerfully bright

Whatever you are choosing to paint, observe your subject first and choose colours that you know will bring it to life – and that you know will make you feel great while using them. I am using orange and yellow shades to bring a sense of cheerfulness and playfulness into my painting time. I know the energy from both colours will be strongly beneficial to my energy levels and also be positively mood-lifting.

Be determined from the beginning of every painting to put your brushes down feeling more cheerful. Make this your goal. For this exercise, I am going to paint physalis plants (sometimes called Chinese lanterns) from my garden. You could paint a row of lemons or oranges in a similar manner instead, if you wish. Whatever your subject, paint an initial shape first, leaving some edges of your chosen subject soft rather than fully detailed. This will give an impression of light hitting the subjects. As it does so, feel yourself feeling lighter and more positive. Let go of any self-doubt and move onto the next stages of this exercise with a feeling of passionate excitement.

What you need:

▸ Clean white paper
▸ Aussie red gold, cadmium yellow deep hue and cascade green watercolours
▸ Large, medium and small brushes
▸ Clean water

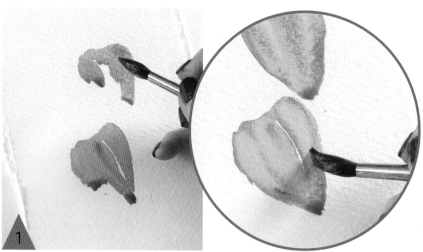

1 Begin by painting your subject in quite a strong colour. Why? Because watercolour always looks far paler when it is dry. In addition, to gain a three-dimensional effect, we are going to lift colour in places too. This technique will only work if you have enough colour placed to begin with. Be strong. Use bold pigment to create your initial shapes. Then with a clean damp brush, create a few lighter areas by gently lifting colour in appropriate places to form the subject's shape.

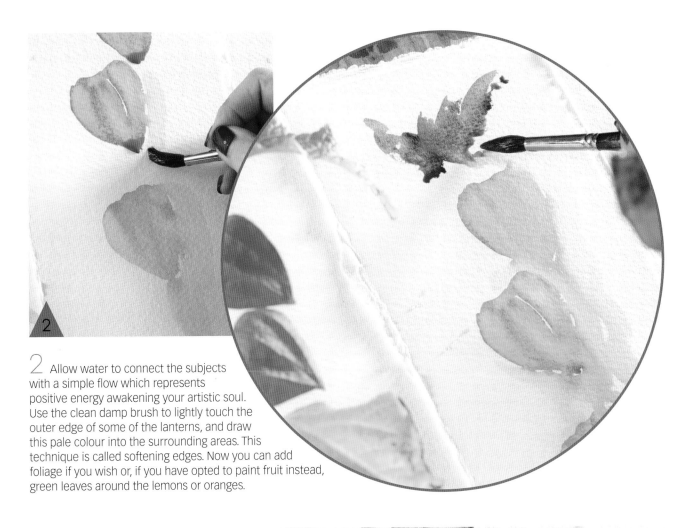

2 Allow water to connect the subjects with a simple flow which represents positive energy awakening your artistic soul. Use the clean damp brush to lightly touch the outer edge of some of the lanterns, and draw this pale colour into the surrounding areas. This technique is called softening edges. Now you can add foliage if you wish or, if you have opted to paint fruit instead, green leaves around the lemons or oranges.

3 When this stage is dry, add detail to complete your piece; but only enough to tell the story of what you are painting.

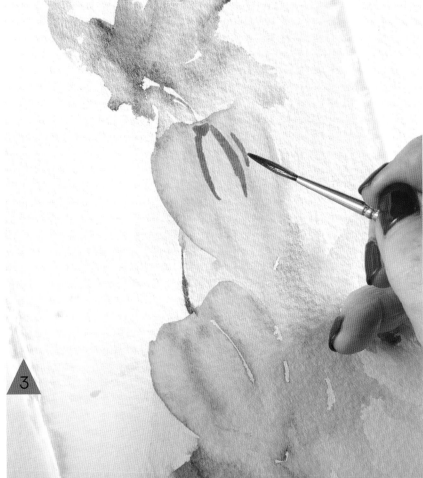

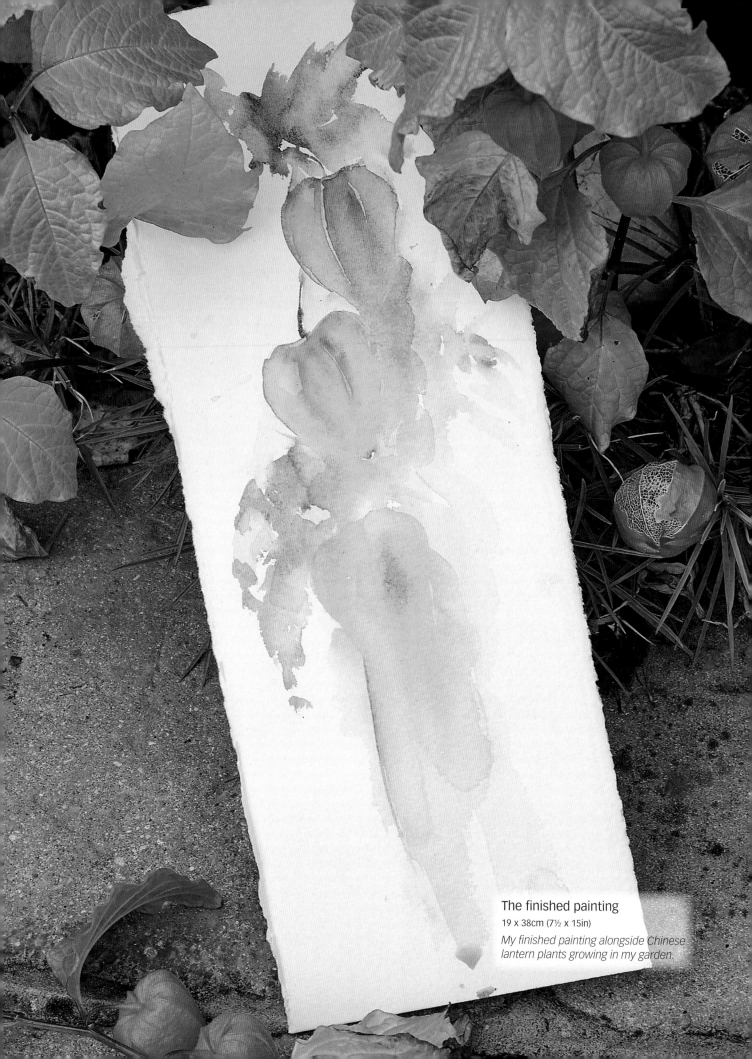

The finished painting
19 x 38cm (7½ x 15in)

My finished painting alongside Chinese lantern plants growing in my garden.

Positive colour advice

Knowing how colours work is a great way to begin creating each time
you paint. Now would be a great time to go back to the beginning of
this book and try all the included exercises again, but this time adding
the positive energizing colours we have just looked at.

Each time you shop for new products to use, think about what they
can do for you and what you need as a person. To absorb positive
energy from each shade, try to buy colours that make you feel fantastic
when you are painting. Intend to use your creative time to feel brilliant.

It is the colour flow that is important, as it can be used to positively
affect your mind. More importantly, never underestimate how powerful
colour can be in your life in general. Just think about the chapter earlier
on in this book where there was no colour, only black and grey. That
was a shock to my own senses to write, but it is an important part of
this book's journey; depicting the essence of the importance of colour
in our lives.

We need colour. And we have the ability to improve the lives of
ourselves, and those around us, by being positive.

Wake feeling positive each day. Always look
ahead with a positive attitude. It makes
such a huge difference to who we are and
how we are seen.

The key word is 'positive'.

Always be positive.

As light as a feather

'I realize there's something incredibly honest about trees in winter, how they're experts at letting things go.'

Jeffrey McDaniel

On so many occasions, we carry our problems and headaches around with us, when we should aim to leave them way behind. I love the saying that we should 'live in the present, which is a gift to us'. The past is the past and it cannot be changed but for some reason letting go of what may have happened years ago, or even yesterday, isn't always easy. However, holding onto any form of negativity is like carrying around excess heavy baggage. It can sap our energy and pull us down. This isn't healthy for the body or the spirit.

I find closing my eyes, taking deep breaths and imagining clear blue skies very helpful for getting to my happy place to paint. Similarly, I love yoga. I think it is a wonderful way to de-stress, relax and improve how we feel. Painting is also a therapeutic way to spend time, and I liken my painting exercises to my yoga routine. Such simple, free, routine exercises can improve our minds and enhance our day.

In art, we improve ourselves on every level with each new brushstroke. To think, live and create positively, we need to get into the 'now' zone in order to be our best selves.

Swan feathers collected from my cottage garden. White, pure and light.

Best

When you are faced with a new challenge, whether a painting or something else in life, try approaching it with a positive attitude.

Believing you can do it before you start can make a huge difference. If you have a lot to do, or a lot on your plate try tackling things a little at a time. Make a dent in the task by doing one thing at a time, and doing it well. Gain a sense of achievement each time you tick off a small achievement from your daily or weekly list of things to do.

For this next challenge I am going to ask you to paint a washing line. And you will need just a few materials to do so.

your
self

Washing line

A breath of fresh air

My earliest memories of my stepmother are watching her hang out the washing each week. She didn't believe in washing machines or tumble dryers, which is so hard to imagine, I know. She came from a family of thirteen and all the men were miners. As the eldest daughter, she did all the washing for the family. She had a really tough life and yet she never grumbled. In fact she loved those washing days. When I asked her why, she explained. 'Jean, each time I took on the challenge of a huge weekly wash I saw it as washing my troubles away.' Everything that had gone wrong the week before was instantly dismissed and a new clean week lay ahead that was trouble-free. She spoke many words of wisdom to me. Now I paint washing on washing lines and think of her, and how she always stayed positive with so little. I am going to try to bring her wisdom into this simple demonstration.

What you need:

▶ Clean white paper
▶ Watercolours in the following colours: cascade green, cadmium yellow deep, helio turquoise, quinacridone gold, amethyst genuine and opera pink
▶ Large, medium and small brushes
▶ Clean water

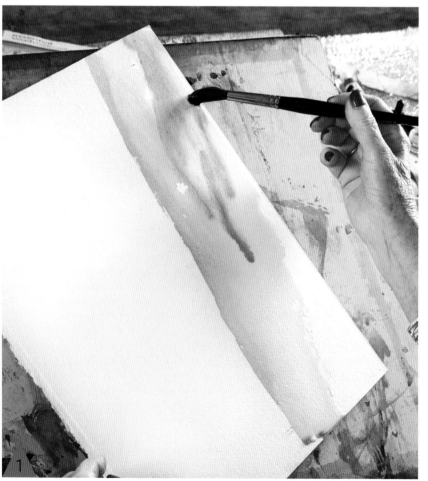

1 Begin by painting the sky in the top right corner. I find it easier to work with my paper propped up as shown, so my blue colour flows across the top in a lovely subtle diagonal, almost straight across the paper.

Each time you try this painting, imagine how you can change the sky. It can be full of clouds or a clear blue. Have fun making these creative decisions. Perhaps you want to suggest that it is going to rain, by opting for grey shades. You can even make the washing really move on the line, as if the day is incredibly windy.

You could also opt for painting the sky by how you feel. If you are happy, paint a clear blue sky. If not, choose grey or darker colours – but while you paint, decide just how you are going to get to that happy mood of painting blue skies only!

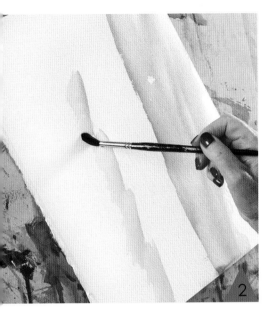

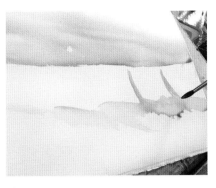

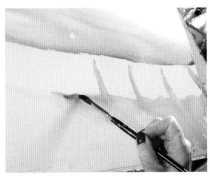

2 Next I add the washing, which can represent the life problems you are washing away or things you would like to change or forget. I start with using water alone to find where my washing edges will be, then add blue colour (helio turquoise). I carefully place it between the white sheets or towels, making them gradually appear by doing so. I then work along the line adding new sheets in this way. You can opt to make your washing varied by placing shirts or other garments on the line. However, when starting out, painting simple square shapes is much easier.

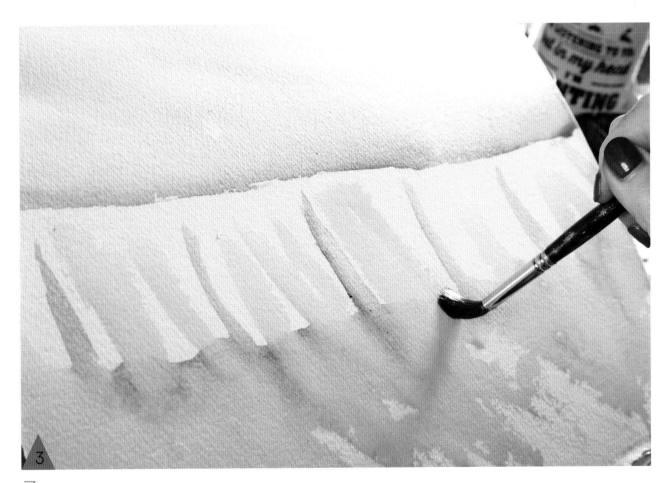

3 I want to connect the washing with the blue background. With a simple move using my clean damp medium brush, I draw an imaginary line, dragging the brush between the white unpainted paper of each sheet and the blue wet area underneath it. The paler blue colour here will merge lightly, flowing upwards into the white space above it. I keep these connecting lines directional in the way the wind would be blowing against the washing.

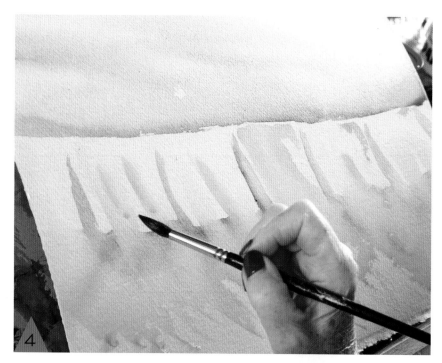

4 To prevent my painting from looking boring, I add a touch of opera pink to some of the white towels. This is simply to make them look more attractive and give the appearance of shadows.

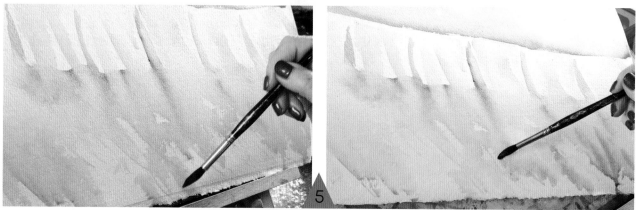

5 I next add the foreground below my washing line, starting from the right and working left. I start with light touches of dilute opera pink, then add cascade green.

Here you can add any colour you wish, but I am keeping my painting very simple. Keeping life simple is easier and in art it is often the same. Having less to complicate matters can be pretty wonderful.

6 Now I start adding detail like pegs to hold the washing on the line. Use a darker mix of the colours on your palette; combining the opera pink and cascade green.

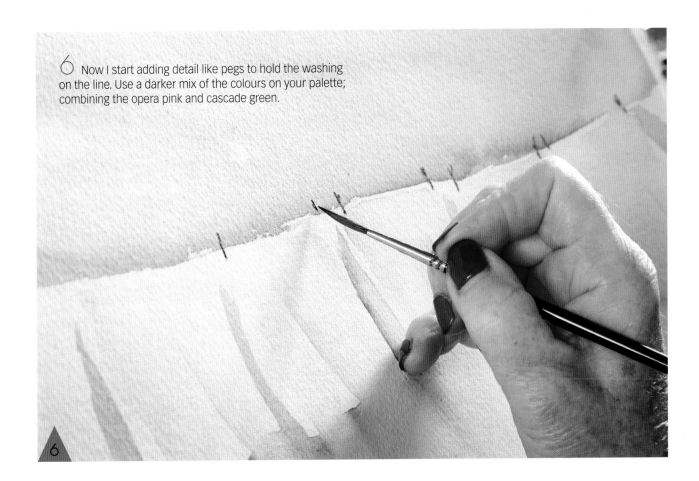

6

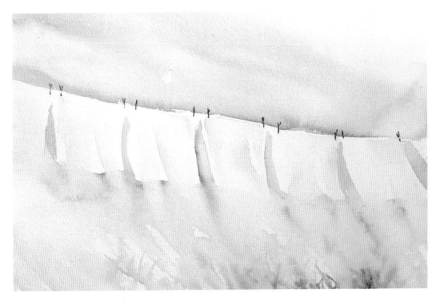

▲
My finished exercise
38 x 28cm (15 x 11in)
A larger picture of the finished piece can be seen overleaf.

Hanging washing out lets you bring clean dry laundry inside, which carries with it a breath of fresh air. While creating this painting, you could think about how you could bring a 'breath of fresh air' into both your painting time and your life. As the painting dries, imagine hanging all your troubles out too and allowing them to be carried away on a breeze. Wouldn't that be wonderful?

Creating as a means to 'letting go' can be so powerful; that sense of knowing you are distancing yourself from anything negative can be freeing in itself.

How about a challenge of painting your next washing line painting with colourful laundry? Each colour could represent your mood as you paint, or where you wish it to be. Have fun!

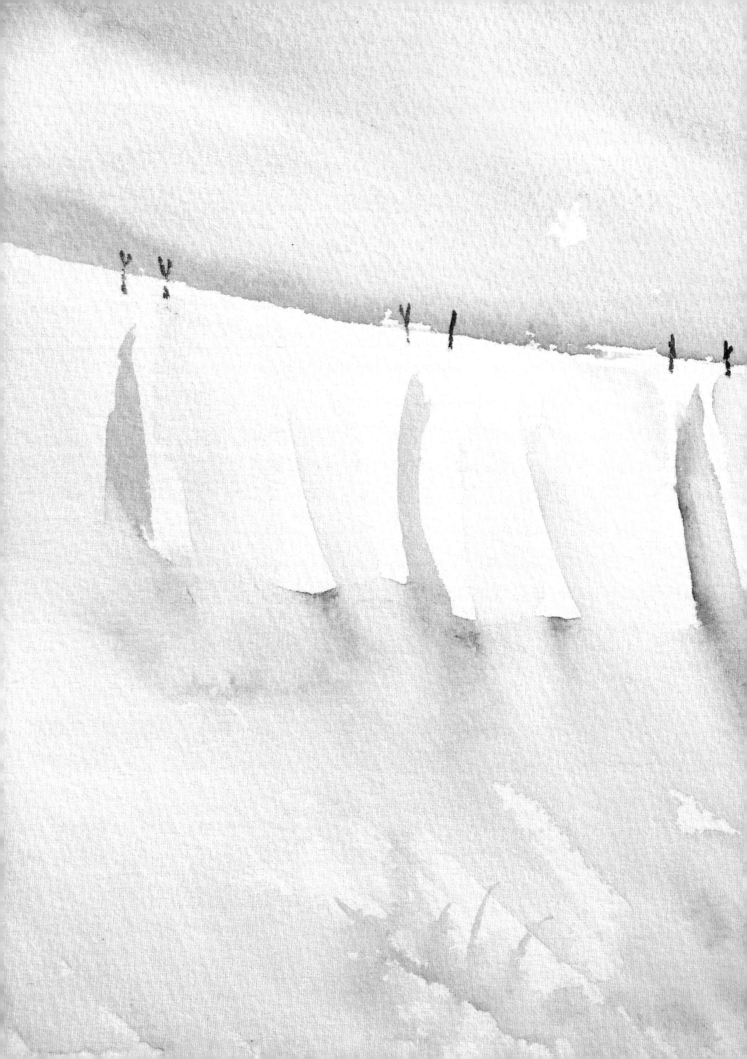

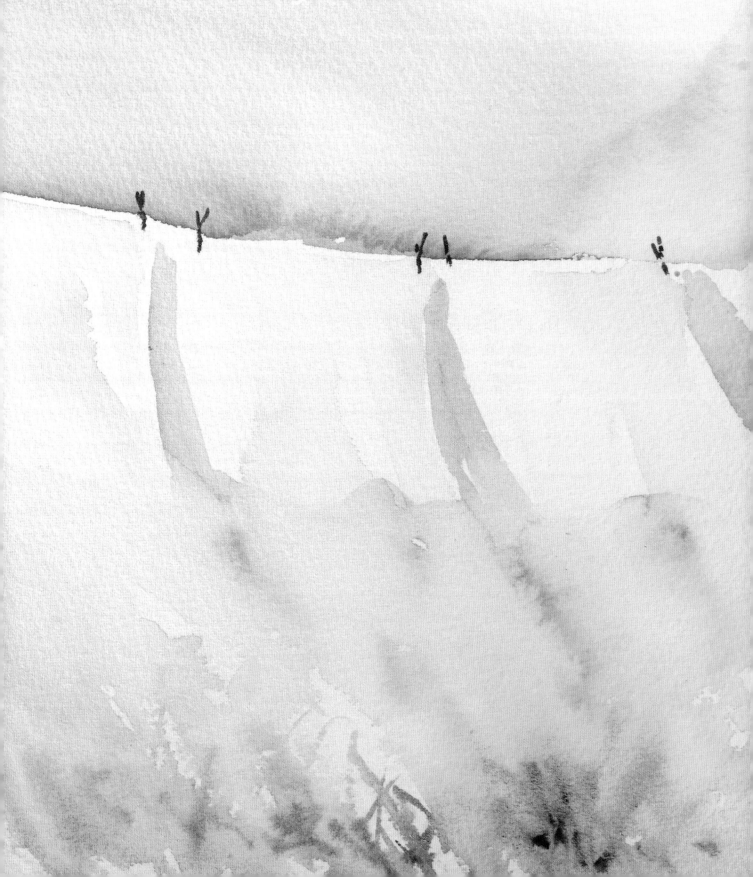

'*When I let go of what I am, I become what I might be.
When I let go of what I have, I receive what I need.*'

Lao Tzu

Let's do it all again

'The difference between stumbling blocks and stepping stones is how you use them.' Anon.

Have you ever enjoyed something so much that you would love to do it all over again? Wouldn't it be fantastic if every single day was one just like that, leaving you feeling energized and wanting to repeat the whole experience? Maybe with even more enjoyment the next time around.

Rather than reaching Heaven's gates in pristine condition, I love the idea of someone wishing to slide through the gates worn out from having such a great time while they were on Earth. I would love my parting words to be 'I want to do it all again' – I mean it!

At the close of my book, I would really love you to have enjoyed the included positive exercises so much that you feel you want to do them all again; this time knowing you will be drawing on even more positive energy and inner creative strength as you do.

Think of the starfish

You have so much power. Power to affect how you feel and approach each new dawn. You alone can choose whether to have successful creative time. You alone can decide whether your painting sessions can be rewarding in that they bring out the best of you. Without a shadow of a doubt, you can paint yourself positive.

A few simple reminders

A new beginning

Find a wonderful starting point to work from, regardless of the subject or challenge that you are facing. Take small steps at first if you feel unsure when painting. Build up your confidence gradually.

Be kind to yourself. Don't be a harsh critic. Love what you do! Feel positive when you pick up your brushes and always believe that you are going to have a great time creating.

Positive colour choices

Listen to your inner artist. Deliberately choose colours that work for what you particularly need at the time of your painting session; whether happy, playful orange colours or strong, powerful red shades. Choose colours not only by how you are currently feeling but, even more importantly, by how you wish to feel. Study and learn about how the colours that you opt for can benefit your mood, well-being and give enriching rewards from your time spent moving your brushes.

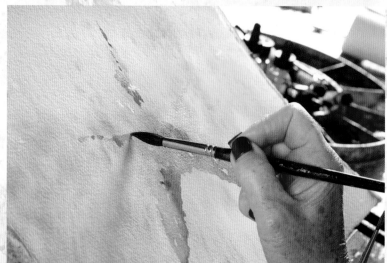

Positive time

Painting can be both relaxing and energizing, but just as with any exercise classes, you need to set aside time each week to practise them regularly if they are to have any effect on your personality and well-being. Decide when you are going to paint each week. Look forward to your creative time. Spend it wisely and soon you will be painting with confidence, which in turn will have a positive effect on the rest of your weekly routine.

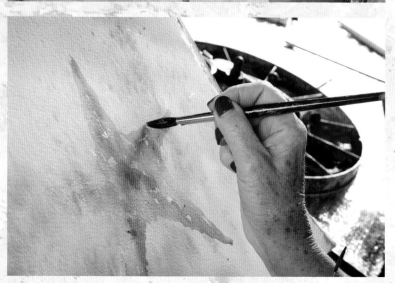

Positive decisions

Never be afraid of what happens when you are creating. Make bold decisions from time to time; perhaps by painting subjects that you feel are totally out of your comfort zone or by repeating painting what you have already painted before. Try adding strong colour next time you approach a familiar subject. Paint it in a new way. Be a new you. Expand your knowledge and painting experience each time you move your brushes.

Bear in mind that by no two paintings are ever the same. Like days or years, some are good, some are better than others. However, we can try to make each fantastic and learn from every one.

I can happily say here that I love my painting mistakes, as I learn far more from these than the compositions that go right. Embrace things that go wrong. These hiccups are what help our personal growth. Handle these mistakes well, smile and see each as the need to pick up a new piece of paper, just as there will always be a new tomorrow, a second chance. Never give up!

Don't sweat the small stuff

Think about how much detail is really needed to finish a painting. Try not to add too much. Don't look for problems. Try to see the beauty in simplifying your work, and your life.

Positively.

In other words, do not over-complicate things.

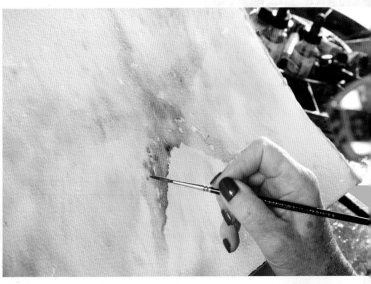

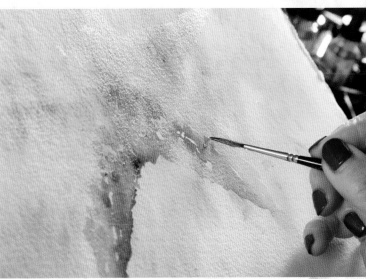

'*You yourself, as much as anybody in the entire universe, deserve your love and affection.*' *Buddha*

Glossary

Because this book is intended to act as a pathway to future artistic adventures, I have avoided using technical terms for the techniques, instead sticking with simple descriptions. This short glossary is provided to help you start exploring the more technical side of watercolour, to help you change your life, positively, through art.

I use my favourite techniques every time I paint. They feel like friends to me and make me feel incredibly happy.

Wash This is where you place colour on paper to cover space. Watercolour washes can be as simple or as complex as you wish, and you can use one colour or more. A one-colour wash can be a wonderfully flowing technique, the action of moving the brush alone a truly positive experience. Think about the movement of your arm and hand as you paint and see this as gentle uplifting exercise. With practise you can create more interesting washes which can act as backgrounds for subjects, as seen on page 76 where colour has been selected to set off the goldfish subject and pond setting.

Splattering A useful technique where a toothbrush is loaded with colour, then the pigment flicked from the brush to paper. This can form wonderful patterns and can break up blocks of colour in a painting to add texture. The splattering method action feels wonderful, freeing and is a great way to disperse any negative energy within you. Think of a problem you'd like to 'flick away' while you splatter! I used this technique in my bluebell scene on page 63. The blue dots represent smaller flowers and give a sense of energy to my work.

Do take your time reading through the exercises on the previous pages, enjoy painting to move forward positively, and always plan to include time to paint on a regular basis. Practise really is our best friend when approaching anything new. Or if we wish to improve what we already know. For now, happy painting!

Negative edges To paint a subject by creating its outline first and then bringing it to life by the background colour alone is called working negatively. You can see how this technique works in the red berry painting on page 40. This is the only time I allow negatives into my life. In art work negative edges can make a subject absolutely shine.

Lifting This term is used to describe when we remove colour, either partially or totally. There are several ways to lift colour, including using tissue which absorbs the colour readily. Pigment can only be lifted while wet or slightly damp and better results are achieved when lifting darker shades. I prefer to use a clean damp brush to lift. I tend to sculpt my subjects this way using straight or curved brush work to do so but you will find your own favourite way of creating the more experienced you become. In my painting of bluebells on page 62, you can see lighter blue sections, where pigment has been lifted to create the small 'bell' shape of the flowers.

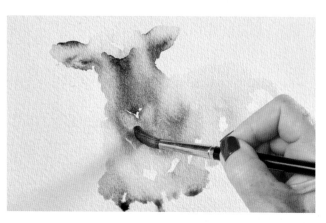

Before you move on...

I would like to remind you that you are an original. Unique. And that is a fabulous point to remember. If we were all the same, the world would be such a boring place. No matter what anyone tells you, be proud of yourself and believe in you. I do!

Don't be a sheep: be unique!

Between me and you

'The best way to gain self-confidence is to do what you are afraid to do.' Anon.

Writing this book has felt like a personal journey and I hope that reading it is a similar experience for you. I have learned a lot about me in every single chapter. My strengths, my weaknesses, areas I need to improve in my life, and areas where I am content. I have looked at where I place my focus, not only in my art but also my life. I believe the key word to positive living is balance. Finding this key isn't always easy.

Art has changed my life in so many ways. I am a positive person. I see the beauty in everything around me, and I look forward to every single day. You can too, if you want to. Now is your beginning, and yours alone.

Take a creative step into a more positive future. Paint yourself positive and enrich your life. Thank you for reading my book and wherever your path leads you, I hope it leads you to happiness.

'Happiness often sneaks in through a door you didn't know you left open.' John Barrymore

Open the door.

Jean Haines.

Index